Scriptwriting for Web Series

Scriptwriting for Web Series: Writing for the Digital Age offers aspiring writers a comprehensive how-to guide to scriptwriting for web series in the digital age.

Containing in-depth advice on writing both short- and long-form webisodes as part of a series, as well as standalone pieces, it goes beyond the screenwriting process to discuss production, promotion and copyright in order to offer a well-rounded guide to creating and distributing a successful web series.

Written in a friendly, readable and jargon-free style by an experienced scriptwriting professor and two award-winning web series creators, it offers invaluable professional insights, as well as examples from successful series, sample scripts and interviews with key series-creators, writers and industry professionals.

Marie Drennan is an Associate Professor in the Broadcast & Electronic Communication Arts Department at San Francisco State University. She teaches courses in television scriptwriting, web series scriptwriting and writing for interactive and online media. She is currently working on *Karlie's Angels*, a web series parody of *Charlie's Angels* in which Karl Marx runs a network of agents dedicated to fighting false consciousness and making sure that bourgeois heroes get what they deserve, and an animated web series called *Unsung*, in which "most hated" TV characters finally get to sing their side of the story.

Yuri Baranovsky is one of the founders of Happy Little Guillotine Studios, a production company on the forefront of online entertainment. HLG Studios is responsible not only for creating one of the first, original web series, the groundbreaking *Break a Leg*, in addition to *Leap Year*, but also for creating and producing some of the web's biggest branded campaigns, including the Slurpee Unity Tour (Winner of the Pro Campaign of the Year Award). Most recently, Yuri and the company produced *Dan Is Dead* for Disney and *Binge*, a dark comedy about bulimia – all of which Yuri also directed and co-wrote. Aside from his work at HLG Studios, Yuri has also written and directed for popular entertainment platforms such as TruTV, CollegeHumor, Fullscreen, NBC Universal, USA Networks and more.

Vlad Baranovsky is one of the founders of Happy Little Guillotine Studios, a production company on the forefront of online entertainment. He co-created and co-wrote the web series *Break a Leg* with his brother Yuri and has also gone on to write for a number of successful branded entertainment campaigns, including two seasons of the highly acclaimed series *Leap Year* and the upcoming Disney series *Dan Is Dead* – for which he also produced the entire soundtrack.

Scriptwriting for Web Series

Writing for the Digital Age

Second Edition

Marie Drennan
Yuri Baranovsky
Vlad Baranovsky

Routledge
Taylor & Francis Group

LONDON AND NEW YORK

Second edition published 2018
by Routledge
2 Park Square, Milton Park, Abingdon, Oxon OX14 4RN

and by Routledge
711 Third Avenue, New York, NY 10017

Routledge is an imprint of the Taylor & Francis Group, an informa business

First edition published by Holcomb Hathaway, Publishers, Inc. 2013

Library of Congress Cataloging-in-Publication Data
Names: Drennan, Marie, 1969– author. | Baranovsky, Yuri, 1983– author. | Baranovsky, Vlad, author.
Title: Scriptwriting for web series : writing for the digital age / Marie Drennan, Yuri Baranovsky, Vlad Baranovsky.
Other titles: Screenwriting 2.0
Description: Second edition. | New York : Routledge, 2018. | Second edition of the author's Screenwriting 2.0. | Includes index.
Identifiers: LCCN 2017058283 | ISBN 9780815376361 (hardback) | ISBN 9780815376378 (pbk.) | ISBN 9781351237857 (e-book)
Subjects: LCSH: Online authorship. | Motion picture authorship.
Classification: LCC PN171.O55 D74 2018 | DDC 006.3—dc23
LC record available at https://lccn.loc.gov/2017058283

ISBN: 978-0-8153-7636-1 (hbk)
ISBN: 978-0-8153-7637-8 (pbk)
ISBN: 978-1-351-23785-7 (ebk)

Typeset in Palatino
by Apex CoVantage, LLC

Contents

Acknowledgments

From Marie Drennan: Many, many thanks to my favorite human, Rob Duncan, for his unflagging support, frequent morale-boosts and inexhaustible willingness to procure treats. Much gratitude to Yuri and Vlad for not fleeing when I went all fan-girl at the 2008 NewTeeVee conference ("Aren't you the *Break a Leg* guys?") and for saying yes to this book. And to my colleagues and students, thank you for your inspiration, diligence, esprit de corps and occasion-appropriate food-fights.

From Yuri Baranovsky: Thanks to Albert and Diana Baranovsky for raising us, loving us and watering the hungry soil of our imagination. Thanks to Marie for finding us, telling us we're writing a book and then making the whole thing happen, and to Vlad for teaching me how to write and letting me steal his favorite toy car to give to that pretty girl in first grade. Thanks to my brilliant wife, Femke Baranovsky, for being my editing fairy and sprinkling the magic dust of proper English on my – I've lost track of the metaphor, but thank you for the endless support.

Thanks to Justin Morrison and Dashiell Reinhardt, the co-founders and co-producers of Happy Little Guillotine Studios, without whom our shows wouldn't exist, our company wouldn't function and my life would include a lot more shoe selling and a lot less art. Thanks to Daniela DiIorio, Hillary Bergmann, Dustin Toshiyuki, Drew Lanning, Hugo Martin and every other actor, crew member and dearest friend who worked with us for what must be a billion hours, often for free, and who did it with unparalleled skill, love and humor.

From Vlad Baranovsky: Thanks to Albert and Diana Baranovsky for filling my head with stories. To Monica and Maya Baranovsky

for being the most supportive, patient and loving family anyone can ask for. To Yuri Baranovsky for always being the voice in my head that says "but you can make this better, right?" Thanks to Marie Drennan for conceiving this book, to Dashiell Reinhardt and Justin Morrison for all things HLG, and to all of the amazing actors and crew who've made our shows happen.

And finally, thank you to all of our fans, without whose support and enthusiasm we would have never gotten into the web series racket in the first place.

About the authors

Marie Drennan began teaching TV scriptwriting before the dawn of the internet and can attest that things are *much more fun* now. When the first edition of this book was published in 2012, there wasn't much talk or awareness about web series, at least not in the mainstream media industry or in academia. (In fact, this book was written because Professor Drennan couldn't find any that talked about web series.) Now, of course, web series are everywhere from YouTube to HBO. It's thrilling to know that, unlike in days past when scripts were graded and handed back and usually forgotten, now creators can get their work up on the screen for all the world to see. Today's creators enjoy tremendous freedom, both in the content of their work and the ways they share it – quietly, with just friends; more broadly, perhaps with some social-media outreach; or even aiming for the stars, literally (you never know when a TV or film star might be ready to sign on for something totally different). And then there's the challenge of telling a complete, compelling story in 15 minutes, or 10, or 2. It forces the writer to "give less" sometimes, but that can turn out to mean creating an entirely unexpected dynamic, mood, plot twist – every challenge becomes an experiment, and it is a great joy to accompany writers along the process.

Vlad and Yuri Baranovsky have been writing for new media since before writing for new media was a thing. The brothers created *Break a Leg* while Vlad was still a creative writing student and Yuri was newly out of community college, where he tentatively studied drama. They begged, borrowed and sometimes politely stole and then returned cameras, lights, locations and just about everything else to make the show possible. The cast and crew worked for free, and for over 3 years, Vlad and Yuri shot *Break a Leg* between

full-time jobs, school, relationships and life. As the series gained popularity online, the brothers, along with two business partners, created Happy Little Guillotine Studios (www.hlgstudios.com), a production company focused specifically on creating original and innovative digital content. With HLG Studios, Vlad and Yuri created multiple large-scale series and branded campaigns, from shows like *Leap Year*, which was eventually sold to USA Networks, to the upcoming Disney series, *Dan Is Dead*, to most recently, *Binge* – a dark comedy about bulimia that has "gone viral" and managed to raise thousands of dollars in a crowdfunding campaign. A full season is currently in pre-production.

Introduction

What are web series (and why write one)?

These are exciting times for writers. Not long ago, if you wanted to create entertainment content for a mass audience, you had to move to Burbank and hope your spec scripts might get read by someone who knew someone who could get you a trial run on the writing staff of an obscure sitcom. Today, digital platforms such as Netflix, Hulu and Amazon have opened up many more opportunities than creators had back in the days when network and cable TV were the only game in town. Now, anyone with the discipline to sit down and write a full script can make a web series and stand a fighting chance of getting it picked up; in fact, many entertainment mega-entities actively scout talent around the web, hoping to find a hidden gem that would probably never even get pitched for TV (witness Comedy Central's *Broad City* or HBO's *High Maintenance* and *Insecure*).

But web series are more than just "snack-sized" versions of TV shows, or TV shows waiting to happen. To understand what a web series is, it's useful to know some history. Although web *shows* of numerous sorts have proliferated so much that it's difficult to imagine the media landscape without them, web *series* really haven't been around for very long.

Before the mid-2000s, not many people had video cameras at hand. And there simply wasn't enough bandwidth to upload videos of more than a few minutes. Fortunately, many independent creators were not deterred by these challenges. As early as 1995, people were finding ways to use the web as a storytelling medium. *The Spot* is sometimes called the first online narrative, although it is

not a traditional one. The format consists of the characters' online diaries, supplemented with photos and occasional short video inserts. Collections of short comedy sketch videos as well as episodic animated shows such as *Red vs. Blue* also proliferated during this period, some amassing views in the high tens of millions.

Yahoo! established a video channel in 2002; Myspace enabled video sharing on its social networking platform in 2004, and Vimeo also emerged in 2004. As bandwidth increased, it became possible to upload longer and higher-quality video. Bands, musicians, comedians and other performers could post videos and promos; artistically minded vloggers created experimental short works that otherwise would have languished in short-film festivals. Personalities such as Ze Frank established weekly or even daily programs that merged comedy, news, think-piece, performance art, interactive audience-participation projects and anything else they were inspired to throw in the mix.

When YouTube opened for business in 2005, it immediately became a magnet for short comedy video producers and viewers. The comedy trio Lonely Island premiered its iconic video "Lazy Sunday" on YouTube. This was the dawn of the "snack-sized" video age. YouTube heavily promoted its ever-increasing stock of short sketches, animations, parody commercials and movie trailers, etc. Comedy-focused sites such as CollegeHumor, which had existed for years, grew exponentially; new sites such as Funny or Die sprang up. The web gave comedy writers who were not stand-up or improv performers a place to hone their craft and develop the digital short as an art form – though again, note that comedy sketches, parodies, etc., are not necessarily episodes of *series*.

It's also important to note here that while *some* of YouTube's early content was seen by hundreds of millions of viewers and is now considered classic, much of that was produced by professional or semi-professional writers and performers. User-generated content was another matter entirely. The fact that anyone with a camera could share their work with the world had an upside and a downside. The upside was that the web had radically democratized media and created tremendous opportunities for independent artists and performers. The downside was that YouTube was flooded with grainy video clips involving cats flushing toilets, skateboard wipeouts and very drunk people saying hilarious things (or trying to). The site was poorly organized and suffered from, and audiences were unwilling to wade through vast amounts of low-quality

content, hoping to stumble upon something they enjoyed watching. YouTube was a great place to show your work if you already had name recognition; if you didn't, you drowned in the sea of user-generated content.

So how could an ordinary person with no performance background get an audience? What about people who wanted to write and produce *series* rather than sketches or shorts?

In 2003, Channel 101 burst onto the web video scene. Each month, creators were invited to submit 5-minute episodes of scripted series, which were screened for a live audience who voted on which shows would continue to the next month's contest. One of Channel 101's earliest (and now most iconic) shows was *The 'bu*, a parody of *The O.C.*, written and produced by Lonely Island trio Andy Samberg, Akiva Schaffer and Jorma Taccone. *The 'bu* drew Lorne Michaels' attention and led to Lonely Island's breakthrough gig creating digital shorts for *SNL*. Over the next few years, Channel 101 shows would feature other big-name performers such as Chevy Chase, Aziz Ansari, John Oliver and Sarah Silverman. Dan Harmon, one of Channel 101's founders, parlayed his success into a network TV deal and created the long-running sitcom *Community*.

But don't get the wrong impression: most of Channel 101's entrants are not comedy stars or Hollywood writers. They're people like you: they have an idea, they write the script, and they find a way to produce the pilot (probably by casting their friends and borrowing equipment). The shows range from the exaggeratedly amateurish and absurd to more sophisticated and cinematic storytelling. Creators are free to play with (or ignore) genre categories, set their stories in any version of reality (or unreality) they wish, go for broad humor or dig deep into emotional and psychological territory – the point is that there are no rules, other than the 5-minute limit and the specification that the show must be a *series*. Channel 101 is still going strong, by the way – something to think about as you're writing your own web series!

By 2005, independent creators were focusing strongly on distribution and monetization. Of course, these were not new concepts; everyone hoped they'd get a huge audience and somehow make some money (maybe) off their show. Many comedians and comedy troupes had made it big on the web, as had many vlogs and shows that today would be called podcasts. But web *series* hadn't quite cleared that hurdle. When Blip.tv opened its site and branded itself as a service that would help the most talented creators bring their

high-quality work to the attention of funders and advertisers, the game changed: now making a web series could be a career instead of a hobby, even for those starting from scratch.

Blip.tv was not the only place for people with such aspirations to bring their work. In 2006, Yahoo! revamped its video site, enhancing its navigability and search function and curating content to help viewers find shows they might like and to encourage new users to explore. In addition, many creators built their own dedicated websites, and some avoided Blip, Yahoo! and YouTube altogether because they preferred to drive all traffic to their main site (which today, it is generally agreed, is a terrible distribution strategy). There was no sure path to success. Dozens of conferences sprang up to address the topic of how to monetize, but they all ended with "we're still not sure." There had been plenty of "big" web series – big in the sense that they had views in the hundreds of thousands and were perhaps making some money through banner advertisements – but no one had yet hit the big time.

In 2006, *Lonelygirl15* became a YouTube smash hit. Some episodes got over a million views, and the series as a whole had over 100 million. The revelation that the narrating character, Bree Avery, was in fact an actress, and that the show was scripted, caused an uproar. Nevertheless, the show ran for another 2 years, accrued nominations and awards from VH-1 and the YouTube Video Awards and generated several successful spinoffs.

2006 also marked the debut of *Break a Leg*, the first online *serial* comedy, meaning that it was structured with an overarching story arc within which each episode furthered the plot. It also adhered more closely to the traditional TV show format, with longer episodes and a long (by web series standards) run of 17 full-length episodes. Unlike almost all web series at the time, *Break a Leg* had a professional feel; it didn't convey a sense that it was conceived or produced as a lark. The show was notable for its high production quality, number of views (about 1.5 million per month) and large cast featuring many established web and television actors. It also, like many web series, broke with television tradition by setting the action in what we recognize as the real world but also added surreal elements such as roving bands of washed-up child actors, living like Gollum in the sewers of LA.

In 2007, Felicia Day created *The Guild*, which attracted a passionately devoted fan base and ran for six seasons, ending in 2013. The show was formatted as a videoblog similar to *Lonelygirl15* (and

innumerable videoblogs since) as the main character speaks candidly and confessionally to the camera/audience from her bedroom. At times, though, the show plays with traditional narrative forms as the action shifts from the vlog entries into present/real-time action, some scenes taking place within the world of an online role-playing game. One factor that helped boost *The Guild's* enduring popularity was its "niche" subject matter and story world: almost everything we see is either live-action scenes of the characters in their own homes while they're gaming or scenes actually set within the world of the game. Day was inspired by her own experience with World of Warcraft and proudly identifies as a gamer geek. She gave the online game community a way to see themselves reflected in what they were watching – something that web series can do, while TV has to aim for high ratings and mass audiences, which can mean failing to respond to, and represent, real people.

The online comedy *Sam Has 7 Friends* was nominated for a *Daytime Emmy Award* in 2006, but it was in 2007 that web series began to be taken seriously as a form of media. After 12 years of giving awards to "sites" that featured scripted narratives, the Webby Awards introduced an official Online Film and Video category that included both long-form and short-form comedic and dramatic series. Jessica Lee Rose, who played Bree Avery in *Lonelygirl15*, won Actress of the Year; Ken Nichols of *Ask a Ninja* fame won Best Actor; and YouTube's co-founders co-won Person of the Year. In 2008, *Dr. Horrible's Singalong Blog* put web shows on the map: starring Felicia Day (whom you will remember as the creator and star of *The Guild*) and the incomparable Neil Patrick Harris and written by Joss Whedon (best known at that time for writing *Buffy the Vampire Slayer*, *Angel* and *Dollhouse*), the musical trilogy was distributed exclusively online and became one of the internet's all-time most beloved web shows. In 2009, the Streamy Awards (the Emmy Awards of web series) were founded, as was the Los Angeles Web Series Festival, the first of its kind. The International Academy of Web Television inaugurated its own web series awards in 2012 – the list goes on and on! Now there are numerous such festivals, showcases and competitions, some quite prestigious, including Raindance, Hollyweb and TOWebfest. In addition, many cities have started their own local web series festivals.

Around this time, brands started to invest more heavily in digital advertising. While much of this content was TV-style commercial spots, a few companies decided to take risks. 7-Eleven did not

one but *two* massive digital campaigns in 2010. The first, a reality show called *The 7-Eleven Road Trip Rally*, created in partnership with Blip.tv and Happy Little Guillotine Studios, was a lower-budget, competition-reality series that saw two teams traverse America while subsisting purely on 7-Eleven food along the way. It was one of the first and most lucrative "branded" series and set the stage for more such projects. Just a few months later, 7-Eleven followed up with the *Slurpee Unity Tour*, launched one day after President Barack Obama mentioned having a "Slurpee summit" with Republicans in a speech. The *Slurpee Unity Tour* was a *Daily Show*-esque series following improvisational comedian McLendon as he traveled the country to bring a purple Slurpee (made specifically for the series) to the President and then-Speaker of the House John Boehner. The show and campaign were a rousing success – garnering *billions* of media impressions.

Slowly but surely, more and more companies started incorporating entertainment (usually web shorts or series) to sell their products. Stories, it turned out, were a good way to connect to target audiences and get them to do the thing that all companies want: buy stuff. As money came in from brands, digital series started flourishing.

Among the first of these was *Leap Year*, commissioned by Hiscox Insurance and distributed by Hulu beginning in 2011. The Hiscox company wanted its site to feature a show that people would watch not because they wanted to learn about insurance, but *because they liked it* and would return to the site to see the next episode. This is not the same thing as product placement; in the entire first season of *Leap Year*, there is only one mention of insurance, which passes almost unnoticed in the dialog, and Hiscox is never mentioned at all. The show itself, while funded and distributed by a company to increase brand awareness, was completely un-branded. With the first season's episodes averaging 10 minutes and the second season going up to a TV-standard of about 20 minutes, the show was one of the first branded digital series to push into a more standard, primetime model. The results were big on both sides of the coin: the brand experienced a 35% increase in insurance buys and quotes, and the creators of the show received multiple awards and an eventual sale to USA Networks.

While independent web series flourished somewhat with the influx of brand funding, few were cross-over hits, and virtually none created a splash big enough to convince TV studios that

digital had the capability to uproot the traditional model. Many of these networks had digital departments, but mostly for show, producing and releasing relatively little content. Luckily, this did not deter independent creators from bringing forth delightful and enduring web series such as *The Lizzie Bennett Diaries*, a present-day re-imagining of Jane Austen's novel *Pride and Prejudice*, which in 2013 was the first YouTube series to win a Primetime Emmy Award for Outstanding Creative Achievement in Interactive Media/Original Interactive Program. (Whew, people needed a lot of words to talk about this stuff back then!) *The Guild*, having swept the inaugural IAWTV Awards in 2012, also continued running through 2013.

The corporate-funding dry spell ended in 2013 when Netflix – a digital-only platform – spent nearly a hundred million dollars (yes, that's $100,000,000) to create *House of Cards*. That kind of money had never been poured on what was, essentially, a web series. Thanks to Netflix's trust in the show's creators (okay, let's say it: the writers), giving them nearly full control over the series, the show was a massive hit. The critics loved it, the fans loved it and everyone was talking about it on social media. Suddenly, the entire order of things shifted. *House of Cards* showed the studios that it didn't matter whether a show lived on network or cable TV, or on a streaming service such as Netflix; if it was great, people would watch it.

By this time, audiences had grown much savvier regarding digital entertainment. Many millennials had become "cord-cutters," unsubscribing from all cable subscriptions and relying solely on digital platforms like Hulu, Netflix, Amazon, etc., for their entertainment. This posed a major threat to television and cable networks, which found themselves having to chase a fickle, even hostile, audience. Seeing Netflix's success, Amazon and Hulu jumped into the fray. Traditional cable and TV networks started taking their own digital departments more seriously as international megabrands jumped on the we-need-a-web-series train, for example *Do Not Disturb*, commissioned by the Marriott International hotel brand and starring internet sensation Taryn Southern. A new trend had emerged: the high-end, film-quality scripted series.

At risk of being eclipsed by cable's new big-budget content, digital studios themselves fought to stay relevant. Influencer management companies like Maker Studios, Fullscreen, Studio71 and others started to throw money at creators, creating influencer-run films like *Camp Dakota* and *Lazer Teams* as well as a slew of their

own series. This new reality has continued up to the present. The number of distribution platforms for digital series has expanded greatly, with significant amounts of money being spent on creating original content. Unable to afford A-list creators, directors and actors, the digital outlets looked to a new type of superstar: online and social-media influencers. The easiest way to get a series funded by a digital outlet is to first become (or get a lot of attention from) a YouTube, Instagram or Vine celebrity; in fact, this is becoming a common career path for those seeking TV and cable deals.

The "Wild West" analogy, bandied about in every festival, panel and conference room meeting, still holds. Every year the industry re-invents itself, and creators have to roll with it, figure out what's working and what isn't and evolve accordingly. It's the only way to survive in an unstable industry where creators who are swimming today might find themselves sinking in 6 months. That said, the key to success is, as it has always been, *quality*. A good show, an honest show, will stand out above the rest. In fact, perhaps the biggest impact that digital content has had on audiences is that they are far more discerning and don't feel the need to settle for "amateur" content such as zany Channel 101 shows or people's fun YouTube projects. (Though some of us will never give up our Channel 101. Never.) Viewers today are not easily fooled – you can stuff your project with celebrities and influencers aplenty, but if the script is weak, if the story is watered down and lacking the ring of truth (even in comedy), it will be all too easy for viewers to click away.

All of this industry-forecast talk might seem daunting – and even somewhat against the spirit of writing and creating *because you want to*, and because it's *fun*. That's the gift the internet gave us at the beginning of the twenty-first century, and it's still there for all who feel the call to imagine, write, direct, film, edit, produce and get their projects out where audiences can enjoy them. Storytelling is one of the greatest crafts humans have developed, and we will never lose our appetite for a juicy tale – and it's now up to you to undertake the exciting, maddening, messy and joyous task of creating one.

WHY THESE SHOWS?

With all of the fantastic web series out there, it was incredibly difficult to pick just a few to focus on, and the ones that were chosen are *not* intended to represent a snapshot of the current online media

landscape, which is vast and constantly changing. Three series – *Brooklyn Sound, Mr. Student Body President* and *Emo Dad* – are discussed in detail in several chapters. They have all won recent, prestigious awards; represent a range of episode lengths (shorter than typical TV shows); and feature sublime examples of series structure, episode structure, idea/premise, character and dialog that illuminate the discussions in each chapter. *Broad City, The Misadventures of Awkward Black Girl* and *High Maintenance* are discussed for the same reasons and also as examples of vignette structure and of web series that crossed over to television.

If you're looking to discover more web series, festivals and competitions such as the Webby Awards, the Streamy Awards, the International Television Festival (ITVF) and New York TV Festival (NYTVF) are a great place to start, as are Channel 101 and Channel 101NY, as well as are the many other sources mentioned in the historical overview earlier in this introduction. When you find a show you like, learn out more about the creators – what else have they done, do they recommend other shows, what else pops up in the YouTube sidebar or in a "because you watched" list? Whether you choose the methodical route of researching your next web series obsession or the cavalier "if it's there, click it" approach, you'll always find yourself with something new and unexpected to watch.

HOW TO USE THIS BOOK

Writing a story – whether it's a short sketch, a TV episode or a 5-hour epic film script – is rarely a straightforward linear process. Many scriptwriting books advise going about it in this order: brainstorm ideas, create characters, craft a show premise and then come up with your plot and story structure. This book asks you to take a different approach, which is to *delay* establishing who and what your show is about, to release yourself from making those decisions (yet) and to take some time to really understand *story structure* first.

It might seem strange that the first chapter of this book is *not* about coming up with an idea for a show, or characters, or a setting. (That process is discussed in Chapter 2.) The reason for this is that it's hard to choose anything without knowing what *purpose* it's supposed to serve. Without knowing what you're going to need from your idea, how can you tell whether it's "good," or how you might refine it? Knowing how stories are constructed, and what

materials you'll need to build those structures in every episode and even across seasons, can help you turn a vague idea into a solid, workable show premise.

It might also seem strange that the first topic is not creating characters. But think of it in practical terms: developing characters is in many ways exactly like filling positions on a team. If you had to pick five people to be on a team, you'd first want to know what kind of team it was and what each member had to do before selecting your players, right? No point choosing a pole-vaulter for a bog-snorkeling team, or stacking your team with shallow-end snorkelers and leaving the deep end unguarded. In other words, if you don't know what positions you have to fill, you can't fill them wisely. This is not to say that an idea for a character isn't a great place to start – it is! But as you think about your characters and let them start showing you who they are, you should be ready with a clear understanding of dramatic structure and *the types of things your characters will need to do, say, think and feel* in order to keep the story moving. You'll have a "job description" for them, which will help you keep them on track as they start to evolve (sometimes in ways that will surprise you). You'll also have a clearer picture of the roster of secondary characters you'll need in order to keep your main characters on their toes.

So before you make any definite plans about your show premise or characters, make sure you spend some quality time comparing the episode and scene breakdowns in Chapter 1 to the shows themselves. Watch the episodes more than once. Get in the habit of analyzing the structure of *everything* you watch. Try graphing episodes of your favorite web series and TV shows and films as well (you'll read about graphing in Chapter 1). With some practice, you'll find yourself easily recognizing the fundamental components of dramatic storytelling and admiring the many ways a deft writer can make their audience feel anything they choose.

As you use this book, feel free to read ahead and start thinking about ideas, premises and characters; inspiration is all around, and there's no need to hold off until you've mastered everything there is to know about structure. You'll probably keep notebooks full of thoughts and ideas, and you'll probably find yourself switching back and forth between chapters a lot, which is great! And when it's finally time to start nailing down the specifics of settings and characters, you'll have a useful playbook to help you keep your story organized and powerful.

And finally – this is probably the most important thing to keep in mind – always remember that *only you* can write the show you have in your mind. It might take a lot of work, or it might happen with surprising ease. Obviously, that's a joke – it's not going to be easy at all! But it will, without a doubt, bring you face to face with your imaginative, ingenious, uniquely creative self.

Story structure 1

So now, let's talk about structure.

You've probably heard of three-act structure: stories that have a beginning, a middle and an end. Aristotle first analyzed and articulated this as basic "dramatic structure," but he didn't invent it. It evolved out of the way our brains process information and organize experiences into systems of meaning. Our earliest myths and legends follow this structure. Novelists, dramatists, poets, essayists and speechwriters have always used it. Audiences generally expect and respond to it. In fact, for the most part, they require it. If a story feels confusing, boring or pointless, it's probably because the structure is weak or missing.

Storytelling is a way of guiding the audience through an imaginary experience: pushing the right button at the right time to elicit particular responses (curiosity, sympathy, indignation, amusement, horror, desire, suspense, relief, etc.). For this imaginary experience to work, the audience needs to get the pieces of the story in the right order. Screenwriters must decide what, how much and when to give the audience *expositional information* to move the plot and attach *psychological and emotional cues* to indicate the significance of story events to the characters and to prompt the desired response from your viewers.

The goal of any story is to draw the audience into another world where people (or characters, which aren't always people) are facing challenges of various kinds – maybe extreme, life-threatening ones, maybe only minor inconveniences. But in all stories, there is struggle. In real life, we can get to know people by talking to them,

and they can talk to us; in stories, we only have one way to understand a character, and that's through whatever the writer gives us. There are also degrees of knowing people; not everyone shares their real, vulnerable selves right off the bat, or perhaps ever. But stories aren't real life; they are carefully crafted versions of life, showing us people (characters) at their most real. To bring a character's real self forward, the screenwriter puts them in situations that prompt them to *demonstrate* who they are, and the most effective way to do that is to challenge them – to let the audience understand what the characters want, why they want it so much, how it feels to them not to have it yet, what they're willing to do to get it. Watching a character have a good day that starts fine and ends fine, with nothing prompting them to show us anything deeper than a casual interest in what's going on around them, doesn't give us any insight and isn't going to feel like we're getting a story.

Imagine telling a friend about your day. If you say, "It was great, I got an A on my history final and then went to a really good yoga class. Later a bunch of us are going to karaoke." Your friend might be glad your day was good, but won't be intensely interested and hasn't learned much about you. That's fine for real life; we don't always have to be revealing our true selves or have drama to report. But stories are different. We do need the people we're watching to experience some drama. Now imagine telling your friend that you saw your ex at the gym, with a new love interest who also happens to be your worst enemy. That's going to get your friend interested. Let's add that you were mortified because you were all sweaty and looked terrible, and you've realized you didn't appreciate what you had, and you desperately want to get back together with your ex. That adds emotional depth because you're showing your vulnerability and revealing what you need. Then you tell your friend that you want to text the ex to see if they feel the same way. Your friend will be highly engaged at this point, probably warning you that, if the ex is already with someone else, that would be disastrous and humiliating. But you really regret breaking up with the ex and can't stand to see them moving on so quickly; this pain drives you to try anything to win them back. You begin by stalking your ex and the new love interest on Facebook, but you get caught, and now you seem pathetic and crazy. You try something else that completely backfires. You keep trying, but you fail more epically each time. Now we've got something we can call a *story*.

Story consists of events and feelings – external challenges and internal struggles. Stories must tie elements of the plot to emotional effects on the characters so that, at every turn, the audience can engage the way your friend did when you revealed your inner torment and your doomed plan. When the screenwriter combines dramatic events and the feelings they bring up, it creates *energy* for the story. This energy is what keeps the audience paying attention. If the energy wanes, interest fades. People will watch shows that are silly, implausible, absurd, ridiculous, you name it – but they won't watch boring ones.

Of course, not everyone agrees on what's boring; to a degree, it depends on viewers' personal taste. You might find a show boring because you dislike the actors, or you're not interested in the subject, or you don't like the genre. But if you set aside personal taste and pay close attention to the structure of the episode, you might find that it is actually well crafted and that all of the necessary elements are in place; the *energy* is there, even if it isn't quite your thing. Every sitcom and drama on TV – even shows you can't stand – has, at the minimum, a solid story structure. The writers might also hate the show (this is not uncommon), but in an extremely competitive field, a job's a job. To get hired at all, a writer has to be competent enough to deliver something that qualifies as a story. So you can generally count on TV show episodes to be examples of strong story structure.

Episodes have, of course, a beginning, a middle and an end. However, that doesn't mean that you simply take a situation and break it into three pieces. Each section has a set of elements it must provide to create the energy that drives the story. These sections are more accurately called the *setup*, *rising action* and *resolution*.

THE SETUP

Of the three parts, the *setup* is the most crucial section of your script. This is where you inject the fuel that will drive your story. It is where you hook the audience into becoming curious, concerned and engaged. Without a strong setup, the audience will not have a sufficient grasp of who your characters are, what is happening to them, what they are doing about it or why it matters to them. In other words, without a strong setup, you'll have an episode that feels flat.

The setup is given in the first scene or sequence of an episode. (Some shows start with a cold open before the titles, which is usually a bit that displays the characters being themselves and which may or may not relate directly to the story.) Very quickly, the audience should be shown three things:

1 a character with some easily identifiable personal qualities,
2 a problem that arises and prompts a response from the character and
3 a set of reasons why the character wants and needs a specific outcome.

The first thing we need is a chance to get to know the character – to learn something about the character's fears, weaknesses, vulnerabilities, quirks, mannerisms, habits, hangups, attitudes. This knowledge enables us to connect and empathize with the character so that, as the story unfolds, we stay engaged and interested in the outcome. You can think of this as "talk-time" – by talking with each other (or maybe to themselves or to the audience in a voiceover), they demonstrate who they are. Because the setup is short, we don't get to know everything about the character right away. But we do need an immediate, clear sense of their fundamental nature so that, when we see the problem arise, we already have a way to connect that problem with some emotional significance to the character. Maybe a character's fundamental nature is that they're naive, or brash, or reckless, or ambitious, or mean, or submissive, or phony, or self-loathing. Maybe the character is a pretty regular person without any extreme qualities; maybe all we can tell about them at first is that they've got a wry sense of humor or are a little snobby or a little shy. But even these "normal" characters have to be differentiated from all of the other characters somehow; they need to be "the wry one" or "the snobby one," etc. The audience needs to form a first impression that, at the very least, will lend some *context* to the problem when it arises. We need to understand the character enough to give us a clue about why the problem is meaningful or significant to them, and how they are going to feel and react.

The second element in the setup is the introduction of the problem, which is sometimes called the "crisis." These are slightly misleading terms in that they imply something dangerous or negative. Another way of looking at it is as a catalyst or change in the status

quo, which could be something positive, such as an opportunity or a sudden stroke of luck. In any case, we aren't entering the character's world at an arbitrary or randomly chosen time; there has to be some reason that the story opens when/where it does. Usually, it opens just before the problem arises. We get a few moments of watching the characters be themselves for context, and then either something happens that shakes up the character's world or the character announces that they need to make a big change in some aspect of their life (in which case the writer must also indicate what *prompted* them to make that decision *now*). Either way, the normal state of things is being disrupted or interrupted, and the main character must respond by taking some action.

Ideally, the problem is something particularly compelling *for this character* – as if it had been designed specifically to motivate or torment this character, which of course it has. We need to see that the problem affects the character in a more intense way than it would be for someone else (which is why we need that talk-time in the beginning to provide context). Say your episode revolves around a character going on a date. A shy person will be terrified and struggle to overcome that weakness throughout the episode, whereas a romantically disillusioned character will have to fight pessimism and a tendency to be self-defeating. This strategic combination of character and crisis generates the tension that engages the audience. We understand what that person is going through even if it isn't what we ourselves, or a different character, would go through. It doesn't matter whether the situation is life-or-death or something most people would consider trivial; knowing what we know about *this character*, we understand *why* he or she is driven to respond. That drive must be strong enough – and clear enough in the script – to sustain a whole episode's worth of struggle.

The third element of the setup is the list of reasons why the problem matters to the character. This isn't actually delivered as a list, although you will usually find the character articulating the reasons much more clearly and succinctly than most people do in real life. Try watching an episode of a TV show or web series and count how many times a character (or someone else in the scene) states outright how they feel and why they need a specific result; sometimes it actually does feel like a list. The more items on the list, the better – that means there's a lot *at stake*. A great way to increase the energy in your episode is to make the stakes high in the beginning and keep raising them throughout the episode. Make sure the audience feels

that a lot is riding on the outcome. Remember, the goal doesn't have to seem like it would be important to us, but we do need to understand why it's important to the character. And for us to really grasp the reasons, we need to hear them from the character. Never assume that the audience will correctly interpret the significance of the problem without guidance from you, the writer. You design the crisis to be particularly problematic to your character as a person, and then you let the characters express feelings and concerns that are specific to the situation. People respond differently to events depending on their own experiences and attitudes, so it's important that you run interference and take control of what viewers understand – or rather, the let characters control it by stating their individual truth.

When we've met the character, seen them encounter a problem or experience a disruption in their status quo and learned how they feel about it and why, we have what is often called "dramatic need." This doesn't mean that the need has to be acted out in a highly dramatic fashion or that the problem itself has to contain high drama. "Drama" here is a term borrowed from theater and refers to everything that happens within the play (or screenplay). Your character's dramatic need involves two components: the *external central question* and the *internal central question*. The external central question relates to the plot: will the character accomplish the stated goal? The internal central question relates to meaning of success or failure to the character: will the character find relief from the negative emotions driving them to solve the problem and attain positive feelings as a result? A strong connection between the external and internal central questions will generate a *felt sense* of the character's dramatic need and will give your story the energy it needs.

The setup ends when the character has decided on a first step to solving the problem. Since we can't see someone decide something, the writer must find ways to "announce" the character's intentions. Often the character will simply say what they plan to do. What matters is that the story has been *set up*: the character is introduced, presented with a challenge and allowed to express feelings about potential success or failure. Dramatic need has been established. The audience has a clear understanding of the external central question and the internal central question. When all of that has been presented, we're ready to get into the heart of the story and watch the drama unfold.

That's a lot to pack into a short amount of time; it takes careful, clever writing to make all of it happen quickly. (Expect to spend a

lot of time revisiting, clarifying and strengthening your setup.) In a half-hour TV sitcom, the setup might last for as long as 3 or 4 minutes. Short-format episodes must get the same job done in much less time. To accomplish this, the traditional structure gets streamlined: it skips establishing a status quo and gets straight to the crisis, or it might even open with the problem already underway and the character mired in an attempt to solve it. Talk-time isn't given its own space at the start of the episode; instead, from the first second, we see the character already in crisis and learn about them *as they react* to the problem and articulate their dramatic need. In any case, no elements of the setup are left out. We still get what we need to engage with the story; the difference is that instead of getting it in sequence, we get it all at once. The writing has to do all three jobs simultaneously: establish character, present a problem and indicate what is at stake.

Let's see how streamlined traditional setups work. We'll use pilot (premiere) episodes, since that is probably what you'll be writing first.

BOX 1.1 Why so serious?

Why are we describing these comedies as if they were tragedies or high drama? Why are the funny parts left out? The point is to demonstrate that every story, whether it is funny or sad or deep or scary, revolves around someone *needing* something and *struggling* against great odds to get it. Even if your story is jam-packed with fascinating characters and oodles of jokes, or the desired goal is hilariously absurd, it's the character's *dramatic need* that drives everything. As an exercise, while you're figuring out your plot and characters, *treat everything like a serious, intense drama.* Go full-on Shakespearean tragedy; don't hold back! It feels a little silly sometimes, but if you can't describe your story in such terms, it might not have enough energy driving it. To make sure, check that you have the necessary dramatic elements in place. If you don't have a strong foundation of clear external and internal goals, strong dramatic need and escalating tension to build on, the show will just feel like a character sketch or aimless series of jokes. ("Character sketch" means that we see a character out of context; the point is to get to know them, not to see them in a story per se. This is different from sketch comedy or sketch drama, which tend to operate as narratives and usually follow the basic story structure, only in miniature.)

Brooklyn Sound is a show about the desperate efforts of a recording-studio owner to keep the business afloat. The episodes follow the streamlined traditional model for a setup. The pilot episode, "Josiah and the Teeth," starts with a cold open in which we see a disturbingly strange family of musicians warming up for their recording session, introducing the running theme of the show: the studio seems to only attract crazies, which isn't great for business. The cold open runs for just over 1 minute; the titles are shown for about 6 seconds.

The first thing we see after the titles is a flustered young woman (Lucy) entering the studio, already in the middle of a phone call in which she's offering someone (presumably someone calling to book the studio) a two-for-one pizza-party deal. Her entreating manner lets us know that she really, really needs this booking. She isn't quite begging, but we sense that it's not far off. When she takes the prospective client's order for pepperoni, we start to understand that Lucy has been reduced to desperate measures including doing menial, somewhat ridiculous things that aren't related to recording music and that would take a toll on anyone's self-respect. In a brief aside during the phone conversation, Lucy acknowledges the sad truth of her situation, ironically agreeing with the caller that the deal is "very much too good to be true."

Another measure of Lucy's desperation is her response when her intern (Pam) informs her that "the documentary crew" has arrived. Frantically trying to close the deal with the person on the phone, Lucy erupts in frustration and says something rude about not having time for the filmmakers. When Pam points out that the crew is are already there, filming, Lucy immediately changes her tune, suppressing her real emotional state and forcing herself to act welcoming. Throughout the scene, Lucy displays personal qualities of determination, creativity and willingness to make painful sacrifices (namely, her pride).

Note that this talk-time doesn't happen before the crisis is introduced, as it would in traditional TV episode structure. The crisis is already underway, and the main character is already deeply engaged in her struggle. The dialog is doing double duty, providing a sneak peek at the story's central problem as well as a felt sense of the character's dramatic need. We don't know all the details yet, but we have enough information to grasp the episode's *external central question*: will Lucy succeed in attracting clients? The audience can empathize with Lucy's plight even though we know very

little about it so far and the internal central question hasn't yet been articulated.

In the next scene, Lucy speaks to the interviewer (whom we never see), trying to appear chipper. She starts to give backstory that establishes the *context* of the problem – what is at stake emotionally. Note that the show's writers are already building dramatic need by giving a *list of reasons why* this matters so much to Lucy and why it is so difficult. First, she tells the interviewer that the studio had belonged to her parents and had quickly become prestigious after recording a (fictional) major musical talent; this gets us thinking about the historical significance of the business and the pressure that puts on Lucy. Second, Lucy relates her parents' death 4 years ago, and though she doesn't elaborate on it, we see that it is difficult for her to talk about; the grief is still fresh. Third, she says that she never expected to be running a business at the age of 24, which reinforces our understanding of how overwhelmed she feels. Fourth, she confesses that she's having great difficulty as the industry has changed since her parents' time and that paying rent is a constant source of worry. Any one of these would suffice to make Lucy's situation feel genuinely desperate; the writers didn't stop at one, though, which is why we're going to believe in every crazy thing Lucy tries as she fights her battle, and why we'll care so much about the outcome.

The scene ends with Lucy trying to put a brave face on the situation, but clearly starting to crack. Now we know the *internal central question*: will Lucy's grief be made worse by feelings of shame and failure if she can't save her beloved parents' great legacy? In the traditional (and streamlined traditional) model, the setup ends when the character indicates how they will first approach the problem. In this episode, we've already seen what Lucy's strategy is going to be: *hanging on to hope for as long as she can*. At 3 minutes in, we have a complete setup. (The cold open was 1 minute long, so the setup itself only took 2 minutes.) That's some efficient writing!

Let's look at another streamlined traditional setup. *Mr. Student Body President* is a show about a hyper-ambitious high school senior who, along with his "staff," seek to rule the school through ruthless *West Wing*-esque power politics. The pilot episode, "Hail to the Chief," starts with a cold open, though this one isn't prelude as it is in *Brooklyn Sound* – it is actually the whole setup. We see the main character, Tyler Prendergast in a sharp suit and tie, being briefed about his morning schedule in a rapid-fire walk-and-talk

with his presidential entourage including his strait-laced, bespectacled, highly organized chief of staff and his PR chair, a sharp, serious, straight-down-to-business cheerleader.

In a mere 20 seconds, we learn exactly who Tyler is and how he runs his administration. He is impatient and demanding and sets extremely high standards of efficiency and effectiveness. He is determined to hold onto power despite not being popular with all students – in fact, there have been calls for his impeachment only a few weeks into the semester. His chief of staff is openly contemptuous of the club opposing him, referring to them as "whiners" whose "impotent rage" can be contained by granting them a bit of "face-time." She also says they "aren't a threat," suggesting that Tyler is a canny enough politician to neutralize enemies.

In the next 15 seconds, we learn about the episode's crisis: the new principal has concerns about Tyler's plan for a homecoming pep rally, specifically the proposed indoor fireworks display. The talk-time continues: the student VP argues with his approach to the school's powers that be and insists that he change the rally's theme, Miley Cyrus' sexual evolution. Tyler refuses because to do so would "show weakness" – an early display of his obsession with power. At 36 seconds in, the final element of the setup – the character's intentions or plans to solve the problem – is given. Tyler, exasperated by the never-ending bureaucracy slowing him down, articulates his strategy to combat it: he will confront his antagonist (Principal Helfrick) head-on and let her know that he absolutely refuses to "compromise his vision." And there we have it: a complete setup in a total of 50 seconds. Note the entire scene consists of talk-time; not a second is wasted, and every word is packed with information about the characters, the world they occupy and the particular situation they face. Other than a brief mention of some clubs having refused to endorse Tyler, the writers dispense with backstory; all is revealed in the discussion of the immediate crisis.

The setup clearly establishes both the *external and internal central questions*. The external question is: Will Tyler defeat his antagonist and carry out his plan for the pep rally? The internal question is: Will Tyler satisfy his craving for power and the thrill of victory, or will he suffer the humiliation of defeat? Both questions are driven by a clearly articulated and an intense dramatic need, given in three manic bursts of dialog: Tyler declares that the pep rally will "set the tone for his entire administration"; it is literally the most important thing that he and his staff will ever do, and it is "legacy-defining

stuff." Tyler's insatiable lust for power, his deep passion and fierce determination – as well as his inflated ego – make the situation feel like a life-or-death struggle. Perhaps we wouldn't set such store in holding student office or organizing a pep rally, but it's clear why Tyler does, because he articulates his reasons. We understand how much is at stake for him, externally and internally, because the writers have made sure it gets put into words. To use an adage borrowed from theater, if it ain't on the page, it ain't on the stage (more on this in Chapter 4).

Both *Brooklyn Sound* and *Mr. Student Body President* contain tremendously efficient setups – but the setup, of course, is only the beginning. Once you have driven your main character into action, you've officially kicked off your story. Now your goal is to keep the audience interested in the plot (the external central question) and caring about the characters (the internal central question). The mechanism for keeping your audience's engagement level high is called *rising action*.

RISING ACTION

Once your character has experienced a disruption of the status quo and has been spurred into action, the rest of the story consists of their struggle to solve the problem.

Establishing a clear, strong dramatic need – the felt sense that the character really needs a certain outcome – gives your story the *energy* it needs to keep driving forward. This is also called *dramatic tension*. A useful tool for checking that your story has energy is a simple graph tracking the episode's overall movement upward from baseline (where the episode starts) to a final peak moment of tension, followed by resolution, as shown in Figure 1.1.

The stars on the graph represent *challenges* your character must respond to as they struggle to attain the goal. These usually manifest as obstacles getting in your character's way, conflicts with other people or personal demons that must be wrestled with. (Some stories will have more than three challenges; it is very rare to have a story with fewer than three.) As the seconds and minutes tick by in your episode and your character struggles to achieve their goal, they must be repeatedly thwarted by antagonists, by the world around them and by their own limitations. Note that the stars grow in size as you move from the beginning to end of the

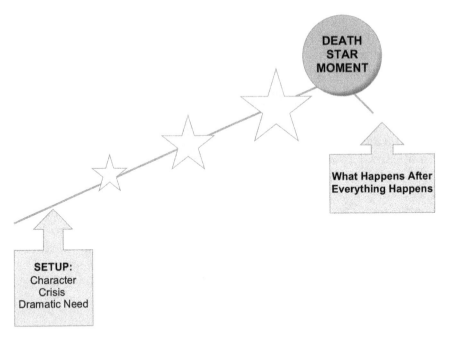

FIGURE 1.1 **The almighty graph**

episode. This reflects the challenges' *increasing intensity and complexity*. Your job as a writer is to keep making your character's life harder. And harder. And harder.

The reason this slope needs to rise upwards is that humans (like all mammals and primates) are wired for alertness to stimuli *until they are processed* as either dangerous or safe. Imagine a deer in the forest, nibbling away at leaves, ears constantly swiveling to monitor for danger. Suddenly, a rustling comes from nearby bushes. The deer freezes, ready to flee for its life. A moment passes; no threat emerges from the bushes. The deer goes back to nibbling, perhaps keeping a closer eye/ear on those bushes. Suddenly, another rustling – but this time, the deer is already primed, its adrenaline is already up, and the rustling is still scary but less so the second time. When no predator emerges after the third and fourth rustling, the deer "learns" that it's probably just the wind. It cares less because it has come to feel safe and unthreatened.

This is the kiss of death for any story (unless the sense of safety is just a setup for an even bigger scare). Once a challenge is dealt with, your audience stops reacting to it and needs an even greater stimulus to return to that attentive state. You need to come

up with challenges that pose ever-increasing levels of threat; make your character's plight feel like it's getting worse by the minute. Don't let your character tread water facing a series of troubles of the same magnitude. If they face a series of same-sized problems, your story flatlines. If they face a variety of small- and medium-sized problems in random order, then you've got a bit of motion going, energy-wise – but it's not rising steadily as it needs to, in order to keep your audience hooked in. Either way, it's likely that your audience will get bored quickly, being deprived of the stimuli and the cues we've all come to expect in stories. Be generous in giving your viewers what they crave: something to get emotionally caught up in (even if that means laughing) and then taken higher and higher as the main character fights through to the end.

In addition to making sure your challenges become steadily more complex and difficult, you can keep your story's energy on an upward slope by continually *intensifying both the risk and the reward* for the main character. Look for ways to keep making the good things better and the bad things worse. If, in the setup, your character's goal is to get a date with someone out of their league, keep giving "evidence" of the love interest's desirability – really build it up! And make sure you present the evidence in bits that go from good to great to amazing, in that order. If your character's dramatic need is to avoid the discomfort of an awkward encounter, make sure that the first challenge proves to be downright embarrassing; the second is painfully so; the third is excruciating. By the end of the episode, the character who was trying to escape an unpleasant feeling has been dunked in a bucket of it, over and over. Mere embarrassment would be paradise compared to the abject humiliation they face (or risk facing) in the end.

The peak at the top of the energy graph represents the moment when the situation is as bad as it can possibly be – hope is all but lost. Think of it as a "Death Star moment." In *Star Wars*, the rebels must destroy the Death Star before it can be completed or else the Empire will become able to wipe out entire worlds: evil will win, forever. The entire film builds to the climactic space battle in which Luke does in fact blow it up. The reason the battle has so much urgency and energy behind it is that we got a perfect "Death Star moment" first – the agonizing moment when Leia sees her home planet vaporized and realizes that the Death Star is already operational. She tried everything to keep it from happening, but at that moment, it seems that she and the entire rebellion have failed. In

your script, the Death Star moment is the one that feels like *there is no way* this can turn out well for the characters; they have exhausted all options; all efforts have failed. And this is where you, the writer, have to get creative and find a way to let your character win (or not, as we'll see in the discussion of Resolutions in the next section). Setting aside the win/lose question for the moment, focus on building a strong, upward-rising wave of story energy that constantly weaves the external and internal central questions together to intensify your character's dramatic need.

Picking up where the setup for *Brooklyn Sound* "Josiah and the Teeth" left off, we see Lucy still talking to the interviewer. As she admits that she could lose the studio soon, she looks stunned, as if she can't process the thought. The dramatic need is intensifying as we learn more about how worried and frightened she is. The tension between her discouragement and her attempts to stay optimistic (or at least appear that way for the documentary) is apparent as she switches almost neurotically back to a state of apparent cheerfulness, expressing her *hope* that the documentary will help publicize Brooklyn Sound. Note that *Lucy's goal in this episode is not to save the studio*. For one thing, from a purely technical standpoint, that can't be her goal because if she achieved it the series would be over. For another, within the story world, Lucy herself isn't looking to save the studio right then and there; she knows it's going to be a long and arduous haul. We need to take her at her word when she articulates her strategy for solving the problem, holding onto hope: "Hopefully you [the documentary crew] can help us get the word out and show people what great work we do here." Lucy is staking everything on her faith that, somewhere out there, there are clients like those her parents had in days of yore – musicians who can bring both artistic glory and solid revenue back to the studio – and she *will not give up hope*.

Here, the external and internal central questions are addressed. The *external goal* is to find paying, revenue-generating clients. As we get further into the episode, all hopes become pinned on the band that's currently in the studio, and the *external central question* gets refined: Will Josiah and the Teeth be the band that saves Brooklyn Sound? The *internal goal* is to keep hope alive; as the episode focuses more on the band, the *internal central question* also becomes more refined: Will Josiah and the Teeth give Lucy any reason to keep her hope alive, even if it's only a drop in the bucket of money that she needs? Stories are at their most compelling and engaging

when the external (plot/event-focused) and internal (felt) central questions combine into a double-whammy dramatic need.

This brings us to the first challenge to Lucy's efforts to keep hoping (the first star on the graph). She has just said that the studio's "great work" will save the day, and immediately seeks to support that notion by invoking her best asset: her "great team." She sounds a little desperate, as if she's entreating the crew, and possibly herself, to believe what she's saying. There is something forced about her optimism; we can see that it takes effort. Right away, we get a hint that Lucy might be fooling herself about her team's greatness. She mentions Pam, whom we see struggling unsuccessfully to carry out the simplest tasks, and only making bigger messes, and being generally weird. In short, Pam is a disaster. She tries hard, and she seems sweet, but she is not a person you'd want to pin your hopes on.

Next, Lucy mentions Joel, her head engineer, whom she describes as "an incredible talent" as we see him yawning, possibly from long hours engrossed in his work, but also possibly from boredom. Joel worked for Lucy's parents before they died; he represents continuity, a connection with both the studio's heyday and her beloved parents. Again, the external (business) and internal (love of family) are intertwined, and we understand how deeply Lucy needs to believe that the team can keep things going.

Joel loves the studio, too. He name-checks a number of (fictional) musical greats who recorded at Brooklyn Sound, holding up their albums. What we're learning about Joel here is that he is the archetypal hipster music aficionado, familiar with obscure bands who were (we assume) too ahead-of-their-time for commercial success or who achieved it and were therefore pooh-poohed by some – but not by him! Joel is not a snob; when he says how much he loves thinking about the music that has been created there, we know his passion is sincere. It seems that Lucy's faith might not be misplaced in this case . . . or is it? Any reassurance that Joel provides is quickly undercut when he says it's "a pleasure to be a part of it" – with a hint of a sigh. The reason for that sigh? The band he's in the middle of recording, which we can guess is fairly typical of the acts coming through of late: kind of crazy and probably neither great nor profitable.

If our hopes haven't sunk already, they are about to. We have already witnessed the crazy-level of Josiah and the Teeth during the cold open. In the context of Lucy depending on them to restore

Brooklyn Sound's grandeur or at least throw a bit of money her way, we can only cringe as we hear them praise Joel's engineering skills – he "knows just what to do with our sound," Josiah says profoundly – while creating the distinct impression that their opinion might be of questionable value (they live in a cave and are grateful just to be in a bigger space). The band's endorsement leaves us even less confident than we were about 3 minutes ago. The first star on the graph has done its job well, shrinking hope and intensifying doubt.

So much for the first of Lucy's two pillars of hope: her team. The second pillar, the "great work" Brooklyn Sound had been known for, is already shaky – how could it not be, given what we've seen of the studio's current client? We are now at star number two on the graph, the second challenge to Lucy's efforts to keep hope alive: the band itself. Lucy, we know, isn't just about the money; she yearns to discover and nurture true talent as her parents did. As we take in the spectacle of the band performing its song, it's hard to find any indication that they will be of use. The music is actually quite impressive (Joel will say later that "their harmonies were tight"), but the people playing it are so profoundly bizarre that any hope of their worldly success is ruled out. When we first met them, their eccentricities were sort of charming; now, they're kind of disturbing and *Deliverance*-esque. Knowing how much is riding on them, we might still be laughing, but our amusement is tinged with a sense of "uh oh."

After the performance comes the documentary crew's inter-view with the band. We learn that Josiah and his (her?) colleagues are quite serious about their career and are recording so they can "get the fan base out there so we can tour." Right away, we're shown the absurdity of this idea: we are told that they aren't mak-ing money, either on the instruments they "craft" or on the music itself. They're doing what they love, but "it comes at a price" says a wild-eyed Josiah as we see one of the Teeth fishing food out of a trashcan. Can't you just feel hope spiraling down the drain?

As a finishing touch, the writers "affiliate" the band with Pam, who represents misplaced hope. At first, Pam seems appropriately spooked when offered a piece of the trash-chocolate, but her eyes widen in delight when the band member feeds it to her, and they form a joyous bond – clearly, she is more like them than she is like Lucy (or any of us). By associating the band with Lucy, a liabil-ity when it comes to Lucy's hopefulness, the writers make it even harder to believe in a favorable outcome. If we were to hear *Joel*

endorse the band or testify to its musicianship, we might be encouraged, but this very pointedly does not happen. In fact, Joel distances himself even further from both the band and Pam, whose role he isn't totally sure about (he thinks she's been there a few months, but it's actually been over two years). As this sequence ends, rounding out the second challenge on the graph, we are barely hanging on, hope-wise; there's just too much crazy in the mix.

The third star on the graph explodes like a klaxon alarm: a call comes from Jillian, the studio's landlady. Now we've got a tangible, immediate, external threat – everything is thrown into panic mode. The writers have infused this villain character with such an array of qualities and powers that it's nearly impossible to imagine defeating her. She's a fast-talking, insensitive, condescending narcissist, so reasoning with her or asking for mercy won't work. She's already lining up prospective new tenants and doesn't care whether she sees Lucy beforehand, suggesting there's nothing to discuss. She says the old lease "belongs in a museum," which tells us that she has no clue about the studio's historical or musical significance. When Jillian refers to the "devil piss" made by the studio, Lucy thinks it means she hates music, which adds to the danger. Lucy's expression of utter horror as she plays the message for Joel is entirely justified. It seems all is lost, but Lucy rallies with a little help from Joel. He points out that Devil Piss is one of the studio's clients, and that they're brilliant. "Dammit," Lucy whispers, "you're right." True to form, she draws renewed strength from her love of music and of the studio that makes it happen.

Note that the sudden appearance of a tangible, immediate external threat forces Lucy to shift her tactics from internal (remaining hopeful) to external (focusing on getting money). She doesn't abandon the "keep hoping" strategy; she says she'll "figure it out," which is what she's been doing all along. She asks Joel how Josiah and the Teeth are doing, hoping for good news. The news is kind of good (the harmonies are tight) but also pretty bad (they insist on only doing live takes so that "they know the Lord is listening," plus Joel knows about the eating-out-of-the-trash incident). Lucy also learns that the band has only paid a deposit, not the full cost of the session. At this point, Lucy's internal and external goals are both on the brink of collapse. She *must* rise to the challenge and take action. She interrupts the session (with apologies, so we know this isn't normal or easy) to ask how the band intends to settle the bill. We've heard Lucy agonize about keeping Brooklyn Sound open,

and we know it's not a selfish goal; she honestly wants to keep it going as a resource for artists; she is trying to keep a whole world alive, not just her private enterprise. We've seen that she's willing to demean herself just to scrape together enough money to subsist and stay open. She certainly doesn't value money over music, or people. So when she interrupts the session, she's going against her instincts and values out of absolute necessity. She doesn't make a huge deal out of it, but we know it doesn't sit well with her. (The writers might also be "protecting" Lucy from coming off as aggressive or *only* interested in money now.)

RESOLUTION

This brings us to the Death Star moment on the graph: the character's final, desperate stab at solving the problem. The challenges seem too great to overcome, and it looks like the answer to both the story's external and internal central questions is going to be "no." Everything is at stake in this moment. The main character has to pull out all the stops and either succeed or fail.

Failure is definitely an option; not every story ends happily. Some don't end tidily, either; the resolution might be externally positive but feel bittersweet, or the character might attain what they had been seeking, only to learn that it wasn't what they truly wanted or that they would have been better off without it. There's no single "right" way to end a story – the only requirement is that the audience clearly understands *how the ending feels to the character*. As interesting as your story's plot might be, we aren't watching just to find out what happens. We are curious because we've invested in the character; we know why and how badly they need the outcome. We have come to empathize with their *dramatic need*. This is what you must focus on in your resolution, whether you completely wrap up the plot or leave it partly open-ended. Whatever happens, your primary responsibility is to let us see what *meaning* it has for the character.

You might have noticed that after the peak, the graph dips downward. This seems odd, since the whole point has been to drive the energy upward. Generally, you don't want to leave the audience at peak suspense (cliffhangers are the exception and are pretty rare except in season finales). Even when we're enjoying it, tension is a form of stress; as a writer, you must make sure that

you're giving the audience what they need to process the end of the story and feel a satisfying sense of "Ahh, that's resolved now" (or "Ooh, that didn't go well" – either way, the suspense is over and the audience can relax). In TV scriptwriting, the dip might represent a tag, which is a bit that plays after the end credits. More often, the dip is simply a quick debrief among the major players, consisting mainly of jokes to help dissipate tension. This is a less intense level of energy than the culminating challenge and desperate last stab; it is a rest, a chance for us to digest what we've taken in.

It is also where we learn What Happens After Everything Happens (WHAEH). Stories don't feel finished until there is a sense of closure, meaning that we get to see and hear how characters process all that has befallen them. We want to know where they land, to put it simply. Maybe they achieve "happily ever after." Probably they don't (or the series would be over). So what kinds of things happen after everything has happened? Destabilized relationships get set right; valor gets rewarded, and cowardice punished; mistakes are forgiven; lessons are learned. We exit the story with a sense that the character's life is has just become permanently more complicated and difficult, or we see them safely return to baseline, ready to repeat the cycle in the next episode.

The WHAEH doesn't have to be a big deal, dramatically; it needn't bring out any new, hidden depths of the story. It's often a light joke or two that reassure us everyone is friends again, or some words encouraging the character to try again next time. Occasionally, we'll get a glimpse of a vanquished enemy vowing revenge. Mainly, the WHAEH is a form of "talk-time" that lets us settle in with the characters just as we did at the opening of the story, in the setup. It's important that your story begin and end with the focus on the character – the audience isn't watching a plot, they're watching someone's (your characters') story. Try to imagine *Star Wars* ending as soon as the climactic battle is over. Technically, when rebels blow up their target, that's the end of the plot. But obviously we can't just walk away at that point, because the plot isn't the whole story. We need to see Luke, Han and Leia reunited; we need to see ranks of saluting rebel soldiers, and medals of honor bestowed. We need to see the characters feeling all the feels – jubilation, relief, affection, grief, hope. And while this is happening, the tension is pleasantly dissipated by comic moments such as Han's flirty wink at Leia and R2-D2's endearing little happy dance. This is the scene that *makes meaning* of the whole, and it has to come from the characters.

In the *Brooklyn Sound* pilot, the "everything" ends with Lucy's final action: interrupting the session to request payment. As the band slinks down and bolts away, and Lucy unsuccessfully exhorts Pam to stop them, we get our answer to the external central question: No, Lucy will not succeed in getting any money. The "what happens after" consists of a humorous image of Pam trailing after the musicians – not to stop them, just to return their tambourine (which she actually seems to have been playing during the session). Thus, we end on an amusing, tension-dissipating call-back to the earlier jokes about weird, sweet little Pam not really fitting into Lucy and Joel's world. We don't even need to see Lucy to understand where she lands; as Pam frolics into the distance, we understand that Brooklyn Sound will just have to keep chugging along, hoping against hope. It's not a painful ending, even though the struggle was painful. It's also not a complete failure; the goal was never to save the studio in this episode – it was to keep hope alive, and that has been achieved. The studio has lived to record another day, and the audience gets to look forward to the next episode.

Here's a graph of the rising action and resolution for "Hail to the Chief." This episode follows the streamlined traditional model of setup, rising action, resolution and denouement. However, it also borrows structural elements from a specific genre: the war movie. In works from *Lord of the Rings* to dramatizations of historical conflicts, you'll find a formula that developed especially for handling epic tales of good versus evil, nation versus nation, ruler versus ruler (or upstart), as shown in Figure 1.2.

The setup doesn't change. It is followed by a few initial skirmishes – the two sides taking each other's measure, looking for weaknesses, making displays of power, vying for small advantages. Then the three-star model kicks in. We get a first and second challenge (negotiations, attempts at espionage or sabotage, minor battles, etc.) escalating in severity. The second one results in near-defeat for at least one side (definitely the side the audience is on), followed by a period of regrouping, forming a master plan and gearing up for one last all-or-nothing push – the third challenge. Then we have resolution and denouement.

In "Hail to the Chief," the first skirmish actually happens in the same scene that contains the setup – no time wasted here! Tyler tries to flatter Principal Helfrick, buttering her up before negotiations regarding the pep rally. It doesn't work. She forces him to accept a not-so-great compromise. Tyler finds that his adversary won't be as

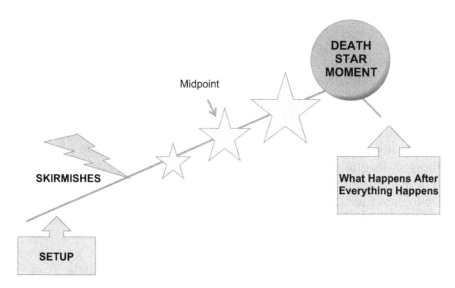

FIGURE 1.2 Epic-tale graph

easy to manipulate as he thought and that she is perfectly comfortable with power games. In this scene, we learn that Principal Helfrick tolerates Tyler's precociousness with a mixture of amusement and strict boundary-setting – she kind of enjoys sparring with him, but she already knows better than to indulge him too much. She is confident, has authority on her side and likes to win.

The second skirmish occurs within the ranks as the core team discovers that the school's star football player has been suspended for appearing in an Instagram picture at a party with a red cup, suggesting underage drinking, and will be prevented from playing in the homecoming game. Hadley admonishes Tyler for failing at his "charm offensive" against Principal Helfrick. When Tyler rebounds quickly with a plan to prevent further suspensions by declaring a moratorium on Natalie Vrendenburgh's birthday party (which sounds like it's going to be killer), his staff threatens to mutiny. Tyler has to back down. Now he has two problems to solve: getting Principal Helfrick to approve the pep rally and preventing "key personnel getting caught in the wrong party pic."

The first challenge – the first direct encounter with the enemy – finds Tyler losing ground. On his way in to see Principal Helfrick, he finds her office swarming with students who have been suspended for inappropriate posts, tweets, etc. They are outraged at

the school's draconian social-media policy; they demand that Tyler put a stop to the policing of they consider normal (even necessary) activity. Tyler knows he has to do something to pacify them. He meets with Principal Helfrick to discuss presidential pardons, clemency and his ability to commute sentences, hoping to spring the football star. But again, his power move is easily brushed aside. Principal Helfrick doesn't even need to try; she simply invokes the "sorry, my hands are tied" line (a weapon always near at hand for those in league with bureaucratic authority) as she hands him the school's Student Code of Conduct. Tyler tries another ploy, his ability to veto the Code itself. The principal parries this thrust with the dreaded "Anyone who has nothing to hide has nothing to worry about" – a creepy tenet delivered with an almost-convincing smile as she brushes past him. Again, Tyler is bested by his enemy, and he is starting to lose crucial support amongst his inner circle as well as the common folk.

But the worst is yet to happen. The second challenge comes as Tyler helplessly watches Bailey Name live-stream her own suspension (for posting sponsored content) to her Instagram followers. Tyler frantically catches up to Principal Helfrick and pleads his case: Bailey is going to be the homecoming queen. There can be no substitute for her (or her 500,000 "Baileyans") – without her, "there might as well not be a homecoming." Tyler quickly realizes the mistake he has made in showing weakness. As if scenting blood, Principal Helfrick sadistically agrees, taunting him with the knowledge that he has brought about his own downfall.

Here, we arrive at the midpoint complication, or "now it's personal" moment, when the character finds or is forced to adopt a new level of commitment to the goal. In this episode, the midpoint complication takes the form of a hero's contact with a wise mentor. This is neither negotiation nor combat; it is a test. Think of Luke training with Yoda in *The Empire Strikes Back*. Luke is sent to a special, secret space (the tree) where he will be tested by forces he can't imagine, and where he must face a terrible truth about himself: he is Darth Vader's son. Tyler experiences something similar. Principal Helfrick suspends hostilities, acknowledging his "chosen one" status (he has "more potential than most") and offering wise but unwelcome counsel. As Principal Helfrick shifts her attention from mundane matters to personal ones, the hallway becomes the testing ground; no one but Tyler can enter this rarified world of close contact with powerful forces. She advises him to stop stressing over

things that won't matter the second he graduates from school. Tyler objects, but it's clear that she's hitting close to home. She presses on, listing the many groups he has ignored, ridiculed or exploited. All of them, she says, "get it" – they know that he doesn't actually care about them and that he is only interested in sharpening his political claws and scoring wins to satisfy his lust for power. The truth confronting him is as painful and as plain as Anakin Skywalker's face inside the black helmet: Tyler has not served his people well, and they do not love him. He is not the leader he likes to think he is. For this, Tyler has no witty comeback, no words at all. Principal Helfrick leaves him with his thoughts. Hadley has witnessed the exchange, but has no comfort to offer Tyler. He will need to regroup before embarking on the final push.

The period of regrouping takes place in the next scene, in the Student Government Room. Tyler is struggling to find a solution. Hadley can't help reminding Tyler that she is "as new at this" as he is. This is the first suggestion we've had that Tyler is, in fact, not a seasoned political mastermind; he's a kid who's never been in the big leagues (if high school can be considered the big leagues). Suddenly, Natalie V. bursts into the room, furious that half of her invited party guests have been suspended and accusing Tyler of telling the other half to stay away. His staff look on in dismay. Things are looking bleak, indeed. This is Tyler's Death Star moment – his subjects are in open revolt, and he is obviously to blame. Natalie's party represents his first major failure. It seems that there can be no way out of his predicament, no way to redeem himself.

But wait! At last, inspiration strikes. In keeping with the grand literary tradition of heroes plucking victory from the jaws of defeat, Tyler turns his greatest threat into an asset: he uses the party itself to solve the problem. Kicking his political jujitsu powers into high gear, he sets out to reunite – and regain control of – his kingdom. What follows is a brilliant display of both ingenuity and cynicism, a testament to both his political genius and his ruthless ambition.

A montage follows, showing us Tyler and his staff mobilizing student groups to ensure that the party house is packed. We see Hadley and the rest of the team distributing beer to Clean Earth Alliance members, who don't really seem to want it, and unobtrusively making a bong appear from behind a couch (this is Hadley, who signals PR to take a quick photo). We see the photos captioned (by the staff) "hall monitors? more like high monitors" and "C.A.E. going H.A.M." We see students passing a bong, doing keg-stands,

making out – and we see Tyler's staff assiduously photographing every single person there. The staff are staging pictures of their peers, gathering "evidence" of activity that is sure to get them suspended.

A voiceover plays over the montage. It functions almost like a Shakespearean soliloquy; although it is not delivered by Tyler himself, it lays out his Machiavellian plan to re-establish dominion through power politics. The strategy is outlined with chilling clarity, deviously couched in the language of inclusion and progressiveness, but dripping with irony. It quickly becomes clear that Tyler has had no epiphany, no humbling lesson. He has not changed his ways to become a better leader; he has only doubled down on his bid for power and become an even more insidious type of tyrant.

And still, when he confronts Principal Helfrick with his new arsenal – the photos from the party – we're rooting for him. Why? Partly because we're rooting *against her*. She has been playing power games from the beginning, toying with Tyler, enjoying watching him flail for a way to outwit or outmaneuver her. By contrast, Tyler (in the first part of the episode) is more precocious overachiever than authoritarian overlord; there is something admirable about his persistence and creative problem-solving. Skill and expertise are qualities that tend to make audiences like characters, even "bad" ones. Plus Tyler is pretty funny. Principal Helfrick is never funny. She's dead serious, and bad news for everyone.

In the next scene, we see a brisk, smirking Tyler striding past the office receptionist, entering Principal Helfrick's office unannounced. Playing the part of a responsible citizen leader, and feigning an innocent interest in helping the principal enforce school policies, Tyler brings the party to Helfrick's attention. She plays it cool, cheerfully informing him that the school has a new policy of judging students solely on their in-school behavior. But as Tyler starts to reveal his hand – he has dirt on the president of the Honor Society, the class valedictorian, even the school band (who is scheduled to play at the governor's mansion). Helfrick becomes visibly uncomfortable, then worried. Tyler has her exactly where he wants her.

As he continues, he sits back, relaxed, clearly enjoying himself. He says he's been thinking about what Helfrick said about how nothing in high school matters. (Cue sentimental music.) The trap is closing. He tricks her into revealing how minor details of her own high school experiences have stuck with her, while the details of

her present life are barely remembered. "Not only does high school matter," he says, knowing she can't argue. Then he goes in for the kill. He leans forward on the desk, his expression turning cold (cue horror-movie music), and delivers the final blow: "It's the *only thing that matters*." But he hasn't won yet. Helfrick counters by reminding him that what he has done is grounds for expulsion. At last, Tyler can play his final, devastating card: he frames the new policy as "profiling one group of kids with punishment while holding others to a less rigorous standard of conduct." Helfrick recognizes that she has been defeated by Tyler's political jujitsu and, with a bitter look, signs the Pyrotechnics Approval Form.

Suffice to say that the Miley Cyrus-themed pep rally is everything Tyler imagined and more. Students revel ecstatically in the bleachers as the fireworks sparkle and spray. Tyler is the star of the show, sporting one of Miley's more distinctive getups, pointing the signature giant white glove. She watches, unfazed. "You want war, Mr. Prendergast? You got it" (cue psycho-killer music). We end on Tyler smiling devilishly in the spotlight, pointing the glove straight at Principal Helfrick. The message is clear: not only is he ready for the fight, he's going to win, and he'll be loving every minute of it.

And so the stage is set for an ongoing conflict between rival powers. We are always going to root for Tyler because he is the underdog, the rebel alliance going up against the evil Empire. There's a tiny bit of evil in him, too, but we forgive – even celebrate – him because he's doing what he needs to do to defeat the enemy, who is our enemy as well – as the ancient Sanskrit proverb goes, the enemy of my enemy is my friend.

What *Brooklyn Sound* and *Mr. Student Body President* share is a focus on characters' dramatic need – the connection between their external goal and the emotions driving them to pursue it (we can count Tyler Prendergast's possibly unhealthy level of ambition as an emotion). This connection is best depicted through between the main character and secondary characters, for instance Lucy's phone call with the potential client, or her interviews with the documentary crew, and Tyler's orders to his staff or his special moments with Principal Helfrick. Note that both "helper" characters and antagonists can serve as the vehicle for highlighting the main character's basic personality traits, mannerisms and emotions. Such interactions allow the writer to craft scenes that *demonstrate* who the character really is, how they feel and how they behave under changing circumstances. This will be discussed more in Chapter 3.

ALTERNATIVE STRUCTURES IN WEB SHOWS

So far, we've been discussing web shows structured identically to traditional TV shows. But an interesting phenomenon has led to variations on that structure: binge-watching. Before the web, if you wanted to watch every episode of a series, you had to wait for a marathon on the cable or TV network, or get the DVDs, or record and save each episode using TiVo or another DVR. This wasn't difficult, and lots of people did it (and still do), but it wasn't the norm; it didn't necessitate any evolutionary changes in the way shows were structured. In contrast, the dawning age of "snack-sized" episodes – which, like real snacks, invite us to consume one after another after another, almost automatically – has seen content adapt rapidly to fit this new online environment. Now, one of the chief characteristics of web series is their bingeability, which has fostered major changes in the way shows are structured both at the episode level and season or series level as well.

Episode-level structures

As mentioned earlier in this chapter, due to the shorter duration of episodes, many web series follow a streamlined structure. The setup provides the same information as a traditional TV show setup – character, crisis and dramatic need – but rather than opening with some "talk-time" to establish character and allow the audience to settle in for the story, it opens with the character already dealing with the crisis. We still get talk-time, but it is already focused on starting to solve the problem at hand. The rising action generally still consists of three main challenges, each more serious than the one preceding it, but these tend to be a bit closer together in time; for example, instead of seeing a character encounter one challenge at home, the next at school, and the next in a hospital, we might see the first challenge at home, the second in the form of a friend coming over after school and relating the challenge, and the third in a phone call from the hospital – it's even possible that all three challenges happen in one long scene. This is common in extremely short episodes (you could even call them micro-episodes) such as those featured in the web series *Emo Dad*. The five episodes in the first season are 3 to 4 minutes long – not a lot of time to tell a complete story with a beginning, a middle and an end!

The pilot episode has a cold open in which we see the silhouette of someone speaking into a webcam; we can barely make out a lip ring and black lipstick, and a room that looks like that of a teenager. This (presumed) young man is making his first vlog entry, an outlet for "the wretched ugliness I must endure in this cruel joke called life." His language is melodramatic and overwrought – "it's been two moons time since Becky extracted my still-beating heart and fed it to a swarm of rabid wolverines" – as he relates his relief now that he has "discovered emo." The room behind him is decorated in a decidedly emo style. His speech lapses into that of a sullen, appalled teenager, railing against his family who, like, doesn't understand him ("Gawd!"). Suddenly, the door bursts open, and a teenager (Chris) confronts the vlogger, who is his dad ("Gawd!"). Their ensuing argument sounds more like two quarreling teens than a father and son as they out-"Gawd!" each other. This cold open efficiently introduces the show's basic premise: a teenager's dad responds to the breakup of his marriage by seeking refuge in a new, emo identity. It also provides the setup: emo dad clashes with his son, who must struggle to preserve his own identity while distancing himself from his father's exaggerated version of it. (This all happens in 44 seconds.) We will see as the series continues that the five-episode *season* actually has a different plot arc, but for now, we are just taking in the story of this episode.

So far, the premise has been established, but the setup is not quite complete. Surprisingly, given its extremely short run-time, this episode has a traditional rather than streamlined setup, with talk-time (the vlogging and the ensuing argument) *leading up to* the crisis, which comes in the next scene. Chris tells his dad to "drop the act," believing that his dad is masquerading as emo just to annoy Chris and get *him* to stop being emo. But his dad (David) pushes back, citing the agony of his breakup and claiming emo as his own, hard-earned right. David's strategy for dealing with the episode's crisis – Chris denying David's emo-legitimacy – will be to *out-emo his son*. The rest of the episode will feature three "stars" climbing upward on the graph and resolve with a Death Star moment and a brief WHAEH.

The first challenge takes the form of David accusing Chris of being a "poser." He fires his first volley of proof that he, not Chris, embodies true emo: he has quit his job so he can stay home and write poetry about his torment. He taunts Chris for being un-emoishly concerned about the cable being cut off for nonpayment; a

truly emo soul "has no use for amusement." So far the score is David one, Chris zero. The second challenge is also a victory for David as he hijacks Chris' friendship with Kyle. Chris comes home in a golf-caddy's uniform (he had to get a job because his dad won't work) and finds David reading his tormented poetry to Kyle, who finds it "amazing." David repeats his accusation that Chris is a poser; score two for David. The third challenge happens when David's accusation is seconded by Kyle – who, crushingly, asks David to teach him to write poetry. As a final, killing blow (Death Star moment), David praises Kyle for being, unlike Chris, "true to the spirit of emo."

Note that in this episode, we really have two perspective characters, each pitted against each other, and hence two storylines – David's struggle and Chris' struggle. David's struggle is really a series of wins; he doesn't suffer anything beyond minor annoyances, which he kind of seems to enjoy overdramatizing. Chris' story is more traditional in that the battle does cause him to suffer. Here is how we would graph the story from Chris' perspective:

Setup: Chris (character) discovers his dad (crisis) dressed in emo style, vlogging about the pain of his recent breakup. Horrified, Chris insists that emo is *who he is* (internal central question) and demands that his father drop the emo act (external goal). Chris' outrage at having his identity co-opted, plus his articulated demand, give us a clear dramatic need. His righteous claim to emo as his true nature constitutes the articulation of his strategy for handling the problem: he will prove that he, not his father, is genuinely emo. The setup is complete.

Challenge #1: David accuses Chris of being a poser. Chris addresses the challenge by pointing out that David is in fact the poser, as evidenced by his taste in TV comedies, and his age. However, he is out-emo'd when David announces he has fully committed to the emo life by quitting his job to write gloomy poetry. Chris loses this round.

Challenge #2: Chris comes home from work, having been forced to take the job in order to pay the bills now that his dad is too emo to work, to find his friend Kyle listening to David recite his "amazing" poetry. He is humiliated at being seen in his caddy uniform and crushed when Kyle agrees with David that Chris is a poser. A second defeat for Chris.

Challenge #3 and Death Star moment: Kyle confirms David's emo greatness by asking if he'll teach him to write poetry. David accepts, saying that Kyle, unlike Chris, is true to the spirit of emo.

Chris is stunned and speechless in his defeat; he has failed at the challenge and, in a cruel twist, also lost a friend. It seems that his quest is doomed.

Resolution and WHAEH: Here, one beat serves both functions: as David and Kyle exit, Chris rallies, mustering a final, outraged "Gawd!" He has lost the battle, but not the war; he will fight (and suffer) another day.

As we continue watching the series, we will find that although David gets much more air-time than Chris, Chris becomes the more compelling perspective character – which is testament to how eager audiences are to tune into characters' struggle, and to identify with the sufferer.

This episode differs from traditional TV structure in that the challenges flow very smoothly as the scenes play out, each blending somewhat into the next. It is hard to pin down precisely where, for example, to divide the first scene into separate challenges. The whole scene is "about" who is or isn't a poser; each line spoken is part of a nearly seamless sequence of beats. In a TV episode, the challenges are much more pointedly depicted and usually are cushioned in some intermediate talk-time, B- and C-story, etc. In addition, the scope of the episode is fairly limited: not a whole lot happens, and most of the "action" is actually dialog. The drama comes from the escalating "ouch" factor rather than from distinct events that seem to bring strife from all directions. While it functions quite beautifully as a micro-episode, it probably wouldn't feel "big enough" to an audience expecting to watch a regular TV show.

Series-level structures

Emo Dad is also a good example of a series whose episodes, when watched together as one five-bite supersnack, form a traditional three-act story. In this model, the pilot episode serves as the setup for the whole season, the following episodes constitute the rising action, and the season finale serves as both resolution and "what happens after everything happens" (or, as we will see, as a kind of cliffhanger or segue to the next season). Of course, most cable and TV shows have season arcs: all dramas feature storylines that unfold over time, and even sitcoms usually have a few ongoing plot-lines such as budding romances (or failing ones) and long-term goals such as advancing a career, etc. In TV shows, series story arcs develop over time in order to keep audiences curious and eager to

watch from week to week. In web series, series story arcs develop rapidly in order to tempt viewers to take the next bite right away, which requires that the whole thing feel like one story, complete with setup, rising action and resolution.

To see what this looks like in action, try graphing the first season of Emo Dad as if it were one story, with each episode representing a challenge in the overarching battle-of-the-emo's between Chris and David.

Setup (Pilot episode): Chris and David challenge each other's emo-legitimacy, each claiming that his true identity embodies the spirit of emo.

Challenge #1 (Episode 2 "The Girlfriend"): Chris' girlfriend, Jasmine, falls under David's mesmerizing emo spell and breaks up with Chris. David wins.

Challenge #2 (Episode 3 "Emo Duel"): When David takes Chris' friends to an emo concert – without Chris – Chris tries to prove his emo worth by carving his name into his arm. David surpasses him by cutting off his own toe. David wins.

Challenge #3 (Episode 4 "Emo Band"): David starts an emo band, The Bleeding Toes, with Chris' friends. Even worse, he raids Chris' diary for lyrics. Chris exposes David, but David outmaneuvers him, saying that people who can express themselves are happy, whereas those who can't truly live in darkness. Jasmine calls David an "emo god." David wins.

Death Star Moment (Episode 5 "The Mom"): Chris capitulates and discards his emo identity. At this point, the central question – who is truly emo, Chris or David? – is answered; it seems that Chris' struggle has ended in ignominious defeat.

Resolution: David is relieved and reveals his (and Chris' mom's) secret plot: to fake a divorce and subsequent emotional crisis, pretend to become emo as a result, and thus force Chris to see how "pathetic" he was being and drop the whole emo thing.

WHAEH: David is thrilled that he no longer has to pretend that his staged "divorce" is real and can reunite with Chris' mom. Chris acknowledges being much happier now that he doesn't have to wallow in emo anymore. We get some lighthearted jokes about David's toe. Chris thanks David and they hug; the relationship is healed – and there's our WHAEH. This would normally be the end of the episode.

But wait! This isn't actually an episode; it's a whole season arc. It needs to draw us into the next season the same way a TV show

would – by ending on a dramatic beat that does not get resolved, but instead functions more like a cliffhanger. Therefore, we get a. . . .

Bonus Surprise Twist: Chris' mom, Becky, arrives with Rick, her new love. In this startling development, David becomes the perspective character whose suffering we tune into. The knife is twisted: Rick offers to take Chris to a Lakers game. David is out-played. He claims to be fine, but after Chris leaves with Becky and Rick, David locks himself in the bathroom and puts on his emo makeup. We leave him devastated, more truly emo than he could have ever imagined. Not only does this give the ending extra punch (and pain), but it's a tantalizing teaser for the next season.

Vignettes

Vignettes are short works that show us a "slice of life" and often focus on a character's inner world: how they experience events, what emotional ripples arise, the deep reasons why they behave the way they do. This doesn't mean that vignettes have to be deep or serious; they can be highly comical. However, they are different from comedy sketches in that sketches tend to present a situation much like those found in sitcoms, framed in or containing a run-ning joke of some kind. Usually, the joke or gag is the point of a sketch; exploration of character, or a character's experience, is the point of a vignette.

Vignettes usually contain the basic markers of a story: a char-acter struggling against internal and external obstacles toward a goal. The difference is that the goal might not be a specific external outcome that can be pursued and achieved (or not achieved) once and for all; instead, it might simply be to get through another day of life as oneself. Vignettes do have a beginning, a middle and end, but the graph might have a less steep incline, not because it lacks interest or energy but because the story is a *glimpse* of the charac-ter's status quo rather than a *disruption* of it.

Many episodes of the web series *Broad City* are structured as vignettes. Not much happens in the sense of there being a setup, rising action, Death Star moment or resolution. The focus is on the characters, Abbi and Ilana, best friends who have known each other since childhood. While they are deeply bonded, they are also sources of mutual frustration for each other – not antagonists, but definitely opposites who frequently criticize and complain about each other's perceived flaws. At times, the show almost feels like a

character study in that "studying" Abbi and Ilana, and in particular their friendship, is the point of each episode. Interestingly, their friendship is a kind of character in itself and is often the heart of the story. The very first episode, "Making Change," is a perfect example. The *plot* is simply that Ilana asks a homeless man to break a $10 bill so she can give him $2, and Abbi goes back to give him the rest of the money. The *story* is the unfolding of the women's argument, which on the surface is about the actual incident – but in truth it is about the two women as individuals and the complex nature of their friendship.

Another web series that exemplifies the vignette structure is *Misadventures of Awkward Black Girl*. The series focuses on Issa's experience as a black woman who constantly fails at things that "typical" black people are *supposed* to be good at, like rapping and projecting a certain form of sassy confidence. She is painfully aware that, at heart, she is more of a dorky white person, and this is what makes her life continually awkward: she doesn't fit anyone's expectations, black or white. Sometimes the vignettes aren't specifically about the identity issue, but instead are simply moments that would be excruciating for any chronically awkward person.

In the third episode of *ABG*, "The Hallway," we see Issa barely surviving the trauma of having to walk down a long hallway as a co-worker approaches in the other direction. Because the hallway is so long, Issa must figure out the appropriate distance for making eye contact and how long to hold it and for speaking or making some other kind of acknowledgment, even if she and the co-worker have already passed each other several times that day. Issa's neurotic unease escalates to a series of semi-hysterical flails; she blurts out strange, off-putting greetings, after which she is wracked with embarrassment. Each vignette shows us a situation that tests Issa's coping ability (which often fails). The episodes are named for the awkward situations she faces: "The Stopsign," "The Icebreaker," "The Dance," etc. Through Issa's internal monologues and private moments speaking to (or awkwardly rapping in front of) her bathroom mirror, we get an intimate view of her struggle with being who she is and occupying her own life.

Yet another good example of vignette structure is the web version of *High Maintenance*. The episodes adhere to traditional story structure and deliver all the necessary elements in the right order, but they're framed as "slices of life" in the sense of proffering glimpses into The Guy's life as a pot-delivery person. In each episode, we

see him deal (no pun, and he's not a dealer, as he explains) with a customer, so there is a situational aspect. The vignette aspect comes from the nature of his response to each encounter: he doesn't have to rise to a crisis in order to solve it in the sense of resolving it once and for all, or making it go away. Rather, each delivery poses both a challenge and an opportunity for him to stay true to his common sense, his values and his basic nature: being helpful and caring (in a semi-detached Zen kind of way) about the people whose homes he is in and whose lives he is briefly a part of.

In the pilot episode, "Stevie," a neurotic and high-strung customer buying for her boss refuses to smoke pot herself, preferring to stick to her wide array of prescription drugs. The Guy recognizes how much she does indeed need to get high to reconnect with herself instead of medicating her feelings away and hangs out with her for a while. He doesn't really have an agenda or a goal; he's just being himself. In the third episode, "Jamie," two markedly eco-friendly and cruelty-free women are tormented about what to do with a mouse they've caught in a live trap, which they can't bring themselves to kill. The Guy handles it himself pragmatically and efficiently in an unpleasant but necessary way. While he's definitely not thrilled about having to do it, his actions are in line with his basic nature, which is explored in a new light: he's not simply a kind person, but rather one whose kindness takes some discipline and strength of character, and manifests in surprising ways. He's also not perfect, and one of the great pleasures of watching the show is getting to know this "chill" character who is also challenged by his own occasional impatience, annoyance, even dislike of a fellow human being. Again, there's no struggle or pursuit of victory over obstacles here, just the character doing what he does and being who he is, which gives the show its intimate, slice-of-life feel. Another feature of the show is that the focus isn't always on the main character; sometimes the secondary characters (usually The Guy's clients) are really the heart of the story and the source of pathos for the viewer, while The Guy is essentially a lens that allows us to look closely at these individuals' inner worlds.

2

Establishing a series premise

You've probably got lots of ideas for shows. Some of them sound like instant hits; some seem like they could attract a cult following; some could be totally loony. How can you tell when you've got a good "good idea" for a series?

The answer is that every idea *might* be a good one. It's not a question of how weird it is (or isn't). In the idea-generating phase, you don't have to rule anything out. If an idea grabs you, let yourself run with it. Just for a while, mute the nagging voice that keeps saying, "But that's too weird, no one will want to watch that," or "But that's too much like a show that's already on." Don't get hung up on "but what about" issues, just trust that you'll find a way around them. This is the creative stage that author Stephen King calls "writing with the door closed." You get to do anything you want, without consequences or criticism.

GENERATING IDEAS

If inspiration hasn't struck yet and you need to generate an idea, start by considering some common starting-points to help get you going. The following is a list of "start with" items that you can build a show around; you might find that playing with some of these leads to new insights about people and places that you know, or things you've experienced, that would make great story material.

Character

This is probably the most common source of inspiration for screen-plays: odd, memorable, one-of-a-kind characters. We all have peo-ple in our lives who have a certain larger-than-life quality, or who are a classic example of a type (but in a wonderfully individual way), or who constantly attract (or cause) drama just by being who they are. Think of your favorite TV characters. How many of them do you suppose were inspired by someone the writer knew?

Even if you personally don't know anyone who you'd like to turn into a show character, you could still build a show around a character of your own invention. How about a high school senior with disturbingly ambitious political aspirations (*Mr. Student Body President*)? Or a 47-year-old dad reinventing himself to force his son to stop wallowing in teen-angst (*Emo Dad*)? Imagine an African-American woman who is painfully aware that she somehow doesn't fit in with black culture (*The Misadventures of Awkward Black Girl*). Let's not forget the classic, simple formula of two best friends just trying to stay true to themselves in this crazy world (*Broad City*). If a show doesn't have terrific characters, no clever plot or premise can save it; go ahead and let them define the show!

Environment

A workplace, a business, a tiny town, an apartment building, a school – any given environment can be rich soil for generating the kind of conflict and drama that make good stories, partly because they *force people into continued proximity* who might not otherwise choose to be together. A workplace or school environment lets you explore power dynamics among management and staff, or admin-istration and students; it lets you play with cliques, in-crowds and outcasts; it opens the door for ongoing romances, rivalries and friendships. The environment itself might also generate plot: in *Brooklyn Sound*, the studio is what motivates the main character, brings in the secondary characters and provides the ticking clock that gives the story its sense of urgency. The environment doesn't even need to be a physical place; in *High Maintenance*, we hardly ever see the main character in the same place twice, but his *job* as a marijuana delivery person serves as the framework for the show. Service-industry jobs in particular place people into relationships that wouldn't otherwise happen; think how easy it would be to

write a show about the crazy experiences of an Uber driver (*Drive Share*) or a nanny with a wealthy clientele (*Precious Cargo*).

BOX 2.1 The story world

Characters need catalysts for action; they need an environment – a location or setting, a population of other characters – that constantly "pushes their buttons." Think of your show as a lab experiment in which your characters are placed in a controlled setting designed to produce constant drama and conflict. This controlled setting is your *story world*.

Your story world isn't simply a location or a setting where the characters interact. It's a very specific type of container for your drama; it largely sets the tone of your show. Imagine if *The Office* were set in a cosmopolitan ad agency like the one in *Mad Men*. Both shows treat themes of corporate life, but the settings (time and place) make each show completely different. The themes of depressing, dead-end office work and of corporate structures that keep smart people down would be lost if the setting were the posh Manhattan offices of Sterling Cooper, where powerful men compete for high stakes and fantastic rewards. Or imagine if *Mad Men* were set in the dreary Dunder-Mifflin building in Scranton, Pennsylvania. Besides the obvious aesthetic difference, what would happen to the *themes* of decadence, glamour and unfettered ambition? What range of actions and desires could the characters have in that environment? The story world largely dictates the story possibilities.

Life events

Sometimes, what makes a great main character isn't that they're extreme in some way; there can be a lot of gratification in watching stories about a pretty regular person whom we happen to meet at a major turning point in their life – a catalyzing event that sends them spinning into a new existence, trying to find their new groove. Many shows depict characters just emerging from a major breakup, and that itself is the story (*Geeta's Guide to Breaking Up*). Or the newly single character might have undertaken a new project or endeavor to help delineate the end of the old life and the beginning of the new, such as starting a band (*I Ship It*). Maybe the character is finally risking everything to strike out on his own in pursuit of a lifelong dream

(*Making Moves*). This can be an especially good choice if you are interested in writing a serial show about characters who grow and change, because your story naturally invites tracking their progress over time (as opposed to more situation-focused episodic shows, where crisis-events are handled and wrapped up once and for all).

What if?

This is one you can really go nuts with (in a good way). Have you ever secretly wished you could do something that would make people think you were a really awful person? More specifically, have you ever wished you could "assist" the suicidal maniacs who lunge into intersections oblivious to traffic because they have their faces glued to their phones and earbuds jammed in (*Lemmings*)? Have you ever wondered how your relationship would be different if you or your partner were still close friends with an ex (*Three's a Crowd*)? We're all surrounded by "what if" scenarios every day, in news headlines and books and songs as well as in our private musings – we just have to slow ourselves down a bit and notice them.

As you work on coming up with a basis for your show, let every idea be a "good one." Stick with each possibility for a little while, just for the sake of exploring how you *might* turn it into a show. Who would the main character be, and what supporting characters would you need? Imagine you got a contract to write five episodes: what kinds of things would happen in each installment? Don't let yourself say, "It wouldn't work." Instead, force yourself to answer: "How would I make this work?" What you're trying to do is practice turning an idea into a framework for a series of stories – in other words, a *show premise*.

CRAFTING A TRADITIONAL SERIES PREMISE

Throughout the history of television, scripted shows have conformed to the conventions of a few genres, mainly situation comedy (usually family- or workplace-based) and drama (including science fiction, mystery and legal/medical/crime procedurals and soap opera). Audiences who grew up watching sitcoms and dramas still expect TV – and now, web series – to deliver what they recognize as *story*: a relatable protagonist pursuing a highly prized goal.

As we will see, today's web series creators have a lot more freedom than TV writers have historically enjoyed: more freedom to experiment with structure, with subject matter, with nearly every aspect of writing. Going on the theory that it's best to learn the "rules" before you decide to break them, here is a discussion of how to craft a *traditional show premise*; the following sections will discuss alternatives that have evolved as web series have matured.

A show premise is an idea that has been shaped and refined to support an ongoing series of stories (episodes). The premise answers the question, "Who and what is your show about?" It is the basic framework of the show, the overarching "reality" that remains constant in every episode. It consists of clearly defined characters interacting in an environment that generates a steady stream of drama and conflict (even in comedies). Some details might change over time: characters change jobs, relationships begin and end, secondary characters come and go, etc. But the elements that generate the drama – *these* central characters, in *these* basic circumstances – remain constant. The premise provides a foundation upon which the writer builds individual episodes.

A strong premise is the glue that lends the series coherence and continuity so that it doesn't stagger along as a loose collection of characters and events. It also allows the audience to gradually develop a relationship with the characters; as we learn more about them each time we see them wrestle with a new challenge, we understand them a bit better. Even if your show is a lighthearted comedy or a darkly ironic drama, and "caring" doesn't sound like what you want the audience to do, your real goal is to sustain interest – which means the audience must care enough about someone or something to find out what happens next. Even when we're laughing cruelly at a character's suffering or rolling our eyes at their bad behavior, we're experiencing a form of "caring" in that we perceive a fellow creature in danger or dire straits; our deer-ears perk up, and we tune in.

Often, a writer will get an idea for a show about his or her friends, co-workers, family, etc. It makes sense: write what you know, right? We all know people who are so inherently interesting, weird or funny that they could easily be the subject of a show. And it's true: many of our friends, co-workers and family members would make terrific characters. Now add a location: say you're going to write a show about the crazy but fabulous people you worked with at the tourist resort last summer. It's a fine idea, but

notice that, at this stage, you still don't have a *premise*. You just have an idea for some characters and a place to put them. Tons of zany stuff might happen, but so far there's no real framework connecting the episodes other than the fact that the audience will see the same actors and the same set each time. Often, the "who" and "where" are easy to figure out; you have to really be mindful that you're building in enough "what" and "why."

BOX 2.2	Shows about friends

Think about it for a moment and be very honest. If you didn't know your friends, would you really watch a show that just featured them doing what they do, being themselves? Of course your friends are interesting to you, because you know them, have shared experiences with them and can put their words and actions in a context that gives them meaning. Even if the video captured their most hilarious 10 minutes ever, or if you were to edit and string together a series of their funniest moments, would people who didn't know them watch for more than a couple of minutes? How often would an audience want to see a new episode? Probably one would be more than enough.

So how do you get from idea to premise?

Let's consider *Brooklyn Sound*. It's possible that the original idea was something as basic as *all theweird bands that record at a local studio*. That's an irresistible idea, but it isn't quite a premise yet. What about *a formerly prestigious studio that now attracts only weird bands?* That's getting closer, but it's not yet clear where the drama will lie – what kinds of things will happen in the episodes, and to whom? We have some sense of place and possibly of characters, but we really don't have the "who" in "whose life is this show about?" So far, it sounds like we're going to see a series of weird bands recording in a studio, which doesn't yet amount to a story about somebody we can relate to and root for.

What's missing at this stage is a clear sense of "who wants what?" In other words, we need to settle on a character and a central question. Let's say we shift the focus of *Brooklyn Sound* away from the weird-band-of-the-week and onto a main character. We could start with this: *The owner (Lucy) struggles to keep the studio*

open despite the crazy clients it attracts. This is progress, but we're still missing the "why does it matter?" element. Keeping a studio open is probably the goal of everyone who owns one; what's special about *this* studio and *this* character? We need to imagine a specific someone having specific reasons. In Lucy's case, we might build in some backstory and come up with: *Lucy struggles to keep the prestigious recording studio she inherited from her beloved parents from fading into obscurity.* Now we've got something we can really work with – a premise full of dramatic need. Each episode will tell a finite story about Lucy's infinite (or at least series-spanning) struggle to keep her parents' legacy alive.

The basic idea for *Mr. Student Body President* could read: *a high school student body president takes his job way too seriously.* This isn't quite a premise yet; it could play out a lot of different ways. Is he hoping that doing a good job will help get him into a top college? Is he floundering because he didn't even want to run and it's a total fluke that he won? Is he an idealist trying to change a corrupt system from within? Is he doing it as a joke? So many options! Imagining the various ways this idea could manifest, we might find that we have a pretty clear idea of who our main character is – not someone earnestly trying to earn a reward (the top-college hopeful), not someone who's just out of their depth (the fluke win), but a kind of politician we don't usually associate with student government: the slick, cunning crypto-dictator. Juicy, no?

At this point, our premise might be something like: *a high school student body president plays power politics for his own gain.* But this doesn't sound like it focuses much on the character; what about that cool "crypto-dictator" bit, why isn't that in here? Again, the character is just the "who," not the "what" or the "why." We still don't know what Tyler *specifically* wants ("his own gain" is pretty vague), and we don't know what is motivating him. Does he want power because he sees himself as a savior figure, or because he was bullied as a child, or is he simply a sadist? Watching the show, we might notice that Tyler's pattern is to conceal his love of power behind a veil of lip-service to the values of democracy and serving the people; the only direction that matters on his moral compass is "win." There's also a lot of ego involved (recall his emphasis on "legacy-defining stuff"). Really, though, whatever Tyler's goals might be (a future in politics, for example), the truth about him is that he just *loves playing the game.* And that's fine – there's no rule saying that his dramatic need has to be any particular thing or take

any particular shape. It just has to be clear and consistent. So our premise might go: *a ruthlessly ambitious high school student body president plays real-world power politics, blurring the line between "governing" and "ruling."* And the central question might be: *Will Tyler stop at anything (or will anything stop Tyler) in his quest for ultimate power?*

Notice how important it is to keep honing your premise until you have a *central question*, whether it's a poignant one like Lucy's or a comical one like Tyler's. Just as each episode will have a situation-specific internal and external goal, your series as a whole should contain some kind of throughline that keeps us in touch with the characters' overall dramatic need. In most shows, the overarching central question is illustrated in each episode, as the character struggles for one "win" in their never-ending quest, but never quite "solved" (or the series would end).

BOX 2.3 **Test pilot**

Check out the "Failed Pilots" section on Channel 101 (www.channel101.com) and Channel 101 New York (http://ny.channel101.com). These are shows whose first episodes were screened – and might have been very warmly received – but didn't get voted into Prime Time. Invest an hour or two and really poke around, note the variety of what's on offer. Ask yourself why the show didn't make Prime Time. Does anything strike you as lacking? Perhaps a bit flat or boring? Is the story confusing? Are the characters unrelatable, or overly familiar? Is the premise high-concept; would you watch a few minutes but soon get tired of the joke and move on? (There is also a "Rejectee Therapy" forum, which is exactly what it sounds like – plus, it's a great way to "spy" on the feedback other writers give and get, which can help you articulate your gut-level response to each show.) There's no right or wrong answer to any of these questions; you're just paying attention to what you respond to in a show, to get a sense of what will be productive and enjoyable for you to write. The best way to deliver a show that's interesting to other people is to write one that's interesting to *you*.

3

Designing characters

Imagine your friends are talking about something that someone did, or something that happened to someone. What's the absolute first thing you want to know? Who it was, of course. Otherwise you have no context, no way to know how to feel. If your friends keep talking without telling you who did it or who it happened to, you'll probably feel a growing sense of urgency to know.

That *urgency to know* is what you want your audience to feel. You want to get them engaged and curious right away, from the very first minute of your story, so the first thing you do is give them a "who." Later you'll put that character in a "did something/had something happen" situation, and you'll have a story. But what the audience needs most is someone to focus on and get to know.

Some shows have characters that are easy to care about, such as Lucy in *Brooklyn Sound*. Why do we care about her? She must, in some way, appeal to us and arouse our empathy. She must be, in some way, like you and me. So: How would you feel if your parents had dedicated their whole lives to their business – more than a business, a passion for nurturing musical talent that might otherwise go unnoticed – and they trusted you to keep it going after they're gone? What would you be willing to do? Or how about Tyler Prendergast – he's kind of an awful guy, right? He's funny, but can we *care* about someone like him? Yes! We can (and usually will) care about anyone we see struggling, because we all have experienced disappointment, frustration, heartbreak, guilt, shame and regret; we also know what it's like to pull ourselves together and keep fighting, or to accept the painful reality of defeat and give up. The point is that any character

can be a serviceable protagonist if you, the writer, give your audience a chance to relate to the struggle – against both *external and internal* challenges.

In designing your characters, you aren't just creating interesting people; you're creating the sources of your show's drama and conflict. Each character is there to be loved or hated (equally gratifying for the audience!) and to fulfill a dramatic function within the story. Your task is to "hire" the best people for that job.

WHAT MAKES A GREAT CHARACTER?

Historically, television characters have tended to display personalities defined by a few obvious traits, usually exaggerated, sometimes absurd. In *The Simpsons*, Homer is the bumbling but well-meaning fool; Lisa is the perfectionist who is hard on others but even harder on herself. In *The Big Bang Theory*, Sheldon Cooper is sarcastic, logical and socially awkward; Penny is scattered and outgoing. As the series progresses, the characters might get fleshed out a little; we might learn more about the characters' histories, we might see them grow a little or learn from their mistakes. But it's a guarantee that at the end of every episode, each character's defining traits are completely intact and unchanged, and will be just as obvious at the beginning of the next episode.

Even if your show is not a comedy, you will find that clearly defined characters help clarify and strengthen your story. They don't need to be heavily exaggerated or unrealistic, but the audience should be able to discern enough about them to understand their need, their drive, to overcome each crisis. And this understanding needs to happen immediately: as soon as the story opens, the character should be revealed and reinforced through dialog and action.

However, even if you want your character to seem real and complex, remember that the audience can't get to know everything about a person in 30 or 60 minutes, let alone 5 or 10. You really only have enough time to show a few basic traits, whether they are exaggerated and clownish or subtle and realistic.

The key aspect of dramatic characters is that their basic nature *limits the range of possible responses* to the world around them. Unlike real people, they can't choose to think or behave one way in this situation and a different way in the next; they have to

be whatever they've been defined as, consistently, no matter what is going on. Whatever the style and tone of your show, clearly defining your characters will allow you to use them in each episode without having to reintroduce them. It gives the audience a "who" right away, no explanation needed, so the story can start right away. Crafting characters is not just a matter of making them interesting or funny; it's also for the sake of clarity and efficiency in the script.

The same wisdom still holds true in the world of web series; you really can't go wrong with clearly defined, consistent characters. But at the same time, you also don't have to limit yourself to characters that "feel" like classic TV-model characters. Life in the digital age has led to an abundance of personal sharing over social media, vlogs, etc., which means we're all basically characters in the story world our fellow humans are constantly engaged with. This might sound creepy, but for writers trying to create vivid characters, it's a huge gift – the audience is hungry for connecting directly to "real" (or real-seeming) people and following their stories. Viewers are becoming accustomed to seeing shows that offer a much more personal, honest take on things. The audiences online are *very* discerning and do not take to falsehoods. There's a reason that one of Amazon's most successful hits is *Transparent*, a show that is built around an impressive collection of intriguing, genuine and profoundly complicated characters. In fact, the show was so successful right out of the gate – and praised to the skies for its unforgettable, can't-get-enough-of-them characters – that many of Amazon's subsequent series (and digital series generally) have followed the same model of intensely character-defined and -driven stories.

Here are some qualities to consider while designing characters that will prove to be memorable, engaging and (of equal importance) *useful* in your story.

Active versus passive

A good character is active, not passive. They have wants, they have needs, and they're actively pursuing them. Even characters who are depressed or whose primary function is to suffer, like Chris in *Emo Dad*, are *actively* depressed and suffering. Chris' attempts to change his situation might seem feeble – trying to argue his father

out of being emo, engaging in "Gawd!" duels – but he's not just sitting there being miserable and doing nothing. No matter how downtrodden, sad or powerless, make your characters *active* in their emotions and you'll have a character who is both watchable and interesting.

Interesting, not "likable"

There is a myth in Hollywood that characters have to be "likable" except those designated as antagonists, or chronically unpleasant people, in which case they are almost certainly secondary characters; witness *The Office*'s primary perspective characters, Jim and Pam, who provide a "likable" anchor in a sea of disturbed (and disturbing) secondary characters. However, shows like *South Park, It's Always Sunny in Philadelphia, Curb Your Enthusiasm, Difficult People* and *Veep* have proven that main characters don't need to be nice in order for audiences to like them. In fact, we are often most drawn to the characters who are the least nice – and the worse they are, the more we love them for it. That's because "unlikable" characters are *interesting*, which can mean honest, or brave, or uncompromising, or clever, or wise, at the expense of being nice. (And if your characters are interesting *because* they're horrid, don't hold back! Really horrid is much more fun than kind of horrid – think Selina Meyer in *Veep* or Erlich in *Silicon Valley*.) So, as you develop your characters, throw "likable" out the window and instead make them real, complicated people with warts and all – it'll be *key* in helping you create a fantastic series.

BOX 3.1 Stay strong

Note: This myth is so prevalent that you might still get a lot of pushback on stories that are too real, too in-your-face, particularly when it comes, sadly, to strong female protagonists. While this is changing (and the popularity of shows like this is on the rise), it's still an uphill battle. But, keep pushing, write the characters that help you tell the best story – it's creators of the future like you that will help shift the industry, and, inevitably, society towards a far more balanced course.

Personality

Some writers create characters as vehicles for their plot – the character needs to do A to get to B, so that the story can end in C. But we watch film and TV to see stories, and good stories have strong characters. So, when creating your characters, think about all the factors that shape our personalities and make us individuals. Ask yourself: What are my characters' strengths? What are their weaknesses? Are they quirky? Are they political? What are their tastes in food, music, people? Do they have friends? Who are the central figures in their lives? Where did they grow up – are they small-town naive, big-city sophisticated, left-coast laid back? In short, *who are they* and how does that make them act? Having a thorough grasp of a character's personality will open doors in your writing that a less prepared writer wouldn't have access to. You'll know how your character would act in any situation, and when your brain throws a curveball at them during a late night writing session, their spontaneous response might surprise you. And that's what writers are always striving for – a character that's alive enough to surprise even their creator.

Desires

Above all else, our characters need to want something. Sometimes, multiple things. They need to want something with every core of their being, it has to drive them, ache within them, pull them on their many adventures. And if they ever get it . . . ? Well, then they'll realize that the thing they wanted wasn't actually the thing that is making them happy. Or maybe they want more of that thing? We humans are a fickle, greedy group – our desire drives us until we get what we want, and then we find more that's missing. Your character's desires are not only what drives them; they are what drives the overall plot. So give your characters something to want, and let them want it a lot!

Suffering

If the audience has a clear understanding of who your character is, they will understand what makes him or her suffer. Your job as a writer, as horrible as it sounds, is to make us care about a character

and then make that character's life really hard. In fact, fiction as a whole – in novels, films, plays and TV shows – is designed to create turmoil, emotional pain and problem after problem for a character. Thus, we need to know the character well enough to appreciate *why* a particular situation is especially difficult for him or her, and to feel invested in his or her struggle. Probably, the situations you create would be challenging for anyone, but *your character is designed to suffer* from that situation more than the average person would.

Keep in mind that their suffering needs to be a special kind of struggle. You need characters whose struggle is big enough to keep them plugging away at it episode after episode. So if you want to write a show about your friends or roommates or co-workers, go for it, but keep testing your premise and your central question. Keep checking that your character is designed for maximum suffering and struggle within the environment and situations you create. Focus on your central question and keep asking yourself, "Why does the audience care?" Ultimately, you're creating these characters so that your show works as a whole, has energy and movement and elicits a genuine response in your audience.

Secrets

We all have them. Some are simply embarrassing stories from our youth, ones that we hope no one else remembers; some aren't earthshattering, but deep and dark enough that we only tell a select few; others are absolutely impossible to confess. What are your character's secrets? Are they hiding things they've done (or haven't done), thoughts they've had, ways they feel? We may never, as an audience, learn these secrets – but you, as the writer, will know them and can use them to shape how your characters think, speak and act.

Malleability

Historically, one rule of thumb for sitcom characters has been that they can never change, and for good reason. If a character's basic nature changes, so too will their dramatic function(s) – if a villain grows a heart, there's no one for the hero to combat; if a meek pushover grows a spine, there's no one for the bully to push around. If one character changes significantly, the dynamics between all of the characters can be thrown out of whack. Still, it's very gratifying

to see a "person" evolve and change over time, to take lessons to heart, to be genuinely affected by their experiences. As web series have pushed against the strict boundaries that defined genres for decades, especially between sitcom and drama, audiences have come to expect characters who, like all of us, learn at least a little about ourselves and about our world as we muddle and struggle along. And, also like all of us, characters should bear a few emotional battle-scars; maybe they try to hide them, maybe they wear them with pride. In any case, those scars should be at least a little visible – as should the benefits of their experience. Perhaps your characters' struggles have made them more confident, or capable, or mature, leaving them not with a scar, but with a kind of emotional/psychological medal. Both types of evolution can enrich your characters and let you take them in new directions as you shape new stories for them.

EXERCISES FOR CREATING CHARACTERS

It's hard to create a living, breathing human being out of thin air. Here are four quick exercises to get you started on creating dynamic, engaging characters for your story.

An email home

Write an email to your character's parents, in the character's voice. Catch them up. Tell them what's happening in your (the character's) life; tell them what your hopes are, why you're writing. Check in with them – what have they been up to? Is there a sick aunt? Is the house being sold? What's their reality? As you're writing this, remember: we all keep things from our parents. We try and present a positive, happy front (*everything is going so great!*), but it's often very easy to see through. What's your character's version of that? What can't they tell their parents, and what are the hints to those secrets that lie in-between the words?

Just having a beer

This is a nice two-for-one exercise. Write a scene in which your main character strikes up a conversation with a stranger at a bar. Go into

the scene armed solely with your notes on your characters and see what happens. How do two strangers talk? When does small-talk stop and real-talk begin? Does the alcohol loosen your character up enough that they say things they ordinarily wouldn't? You can modify this exercise by placing the characters in different one-on-one situations that are likely to elicit revealing, genuine (or deliberately non-genuine) conversation and that put a certain kind of pressure on the character: a first date, a wedding reception, a therapist's waiting room, etc. Write for as long as you can, write even if that results in a 20-page scene. No one will ever see it; it's *purely* for your own use in developing your characters. You might find that some of the dialog comes out trite, boring or pointless – much small-talk is – but a lot of it will teach you not only about your character's personality, but how they speak, their cadence, their reaction to alcohol, their ability to talk to strangers and a host of other things. It might also give you some ideas for deepening your scenes and illuminating your characters further by using subtext, even in ostensibly unimportant chatting.

Journal entry

Write a journal/diary/blog entry that happens on a random day of your character's life. It could be something that happens in your series; it could be something that happened years before the series starts; or, if you're feeling particularly experimental, years after the series ended. Unlike the email to your family, a journal entry is far more honest and personal – it's a great way to really get to know what's in your character's mind and heart. That said, *always keep their personality in mind*. Don't make the entries be simple first-hand accounts of what happened during the course of their day. Focus on their reactions to people and events. We learn a lot about someone when we know who and what irritates them, baffles them, plunges them into despair or gets their hopes up. We also learn about people through their degree of clarity, including with themselves. Does your character rationalize, minimize or avoid thinking too much about someone or something? Are they fooling themselves in some way? What about honesty? Would your character spill their guts in their writing, or would they equivocate (or outright lie) even in their private thoughts? Knowing how your character thinks and feels about their experiences issues will help you craft situations that demonstrate who they really are.

Dating profile

Here's a fun one. Go to any online dating website and make your character's dating profile. Find a picture that you think might look like your character, answer all the questions, write the bio – fill out every inch the way you'd think they would fill it out. Remember, people act differently when they're trying to attract a significant lover. We puff ourselves up, try to be funny and, well, lie to make ourselves look better. Do this for your lead character, do this for your antagonists, do it for any character you want to really explore – it's a surprisingly fun and enlightening exercise. (And if you use a name or picture of a real person, you'd better keep that profile set to "private" – and delete it the second you're finished!)

SECONDARY CHARACTERS

Not even the most fascinating and cleverly developed character can carry a show by himself, herself or itself. Without other characters to interact with, be "triggered" by and be revealed through, there's no hope of a story. We need the energy of conflict and struggle to get engaged with characters and to invest in the outcome of their struggles. In terms of generating a compelling plot with tension and energy, the most important secondary characters in your show will be the antagonists – the people who push your main characters' buttons and strive to thwart their efforts. Antagonists can be formidable adversaries with the power to destroy the main character's chances of success, or they can be troublesome pests who needle and annoy, or anywhere in between. The important thing is that they *serve the story* by forcing the main character to work harder toward the goal, get more resourceful and creative (or just more desperate) and reveal what they're like under pressure.

Antagonists: tormentor, threat, rival, villain

Antagonist characters can help clarify what the main character is up against by personifying the forces ranged against him or her. In other words, the main character's worst nightmares are made manifest in the person of, say, a tormentor, a rival or a threat. In this way, the drama is both external (the antagonist character) and internal (the main character's own fears, weaknesses, vulnerabilities).

Antagonist characters can belong to one category or function as combinations of types.

Threat

Main characters are always being threatened: by society, by the people around them, by their own frailties. A threat character is one who has the power to cause the main character to fail, and sometimes to inflict other kinds of lasting harm, such as heartbreak or humiliation, material loss or alienation from peers, co-workers, etc.

In *Brooklyn Sound*, we find a classic threat character in Jillian, Lucy's landlady. Jillian is central to the plot because she has the power to thwart Lucy's efforts by not renewing the lease on the recording studio; thus, she serves the crucial function of giving the main character someone to struggle against. She also has the power to cause lasting harm, because the studio isn't just a business that Lucy is trying to keep afloat (the external goal). It's also her only connection to her deceased parents; honoring their achievements and keeping their legacy alive is her way of dealing with her grief (the internal goal). Jillian is an especially scary threat not only because of her motivation (making money) but also because of her other inherent qualities: her narcissistic lack of compassion, nonexistent attention span and utter disdain for music and musicians. The problem isn't that Jillian particularly dislikes Lucy or has any investment in seeing her fail; it's that helping Lucy would require her to be communicative, compassionate and reasonable, which she clearly is not. She is dangerous *by her very nature.*

Another well-constructed threat character is *Mr. Student Body President*'s Principal Helfrick. All of Tyler's ambitions and plans depend upon her approval; thus, she has the power to thwart his efforts. In addition, her nature makes her dangerous: she enjoys exercising power, doesn't seem to like students in general and does not look favorably upon upstarts like Tyler. She also has the power to cause lasting harm to Tyler by undermining his sense of purpose and sapping his will, as demonstrated in her devastating "none of this matters and you're not very good at it anyway" speech to Tyler in the pilot episode. Helfrick represents a threat to Tyler's achievements (external goals) goals and his confidence in being a natural leader (internal goal).

But an even more powerful and compelling threat arises in *Emo Dad*. As the father (David) delves deeper into his newfound emo identity, he begins to overshadow his son (Chris). David continually raises the emo stakes, which threatens Chris' status (external concern) and identity (internal concern). He has the power to completely ruin Chris' social life by embarrassing him and lowering his friends' opinion of him; he also has the power to damage Chris' sense of self by co-opting emo. The threat that David represents is far more insidious than Jillian's or Principal Helfrick's: in Chris' case, the threat is in his own home and central to his personal life, is someone he has an emotional investment in and possesses an authority far exceeding that of a landlady or school official. As if this weren't enough, David becomes *dangerous by nature* as he embraces the darker aspects of emo, abandoning mundane sentimentality (including compassion for his son). All of this gives an extra boost of "ouch" energy to both the external and internal threats posed by David.

Rival

You've also seen plenty of *rival* characters: people who want the same thing as the main character (when only one of them can have it). They are after the main character's love interest, job, status, etc. The rival's abilities make the main character feel insecure, inferior, perhaps even unworthy. Like all antagonists, to be dramatically effective, the rival needs to have the power to make the character suffer in both external and internal conflicts.

Principal Helfrick functions as a rival at times, in that Tyler does find ways to gain the upper hand and (temporarily) wrest power away from her. In this way, they become engaged in a rivalry for control of the school. Of course, her superior position precludes Tyler from winning the war, but there are certainly times when he wins the battle. And in the last scene of the pilot episode, she herself articulates the rivalrous relationship that she and Tyler will have for the rest of the series. She is dramatically effective in both capacities, as a threat and a rival. Principal Helfrick is also a minor rival when she promotes her own alternative theme for the homecoming dance and even gloats a little when his efforts are thwarted by Helfrick.

Sometimes a rivalry can be one-sided. For instance, in *Emo Dad*, even though David is constantly trying to out-emo Chris,

Chris is not interested in a rivalry. In fact, competing with his father is a nightmare for him. All Chris wants is to be allowed to be himself, unprovoked and unimpeded. He doesn't rise to the challenge David poses; he doesn't fight back (except in their frequent "Gawd!" duels). But as David repeatedly trounces Chris in the emo-Olympics, even going so far as to cut off his own toe, he takes Chris' friends as his prize. The worst comes when Chris' love interest, Jasmine, falls in love with David. Losing to a rival at romance is always painful, but agonizing (not to mention icky) when the rival is one's totally embarrassing dad.

Tormentor

Stories, like life itself, are chock full o'tormentors. Some are funny, some are infuriating; some are malicious, and some aren't even aware of what they're doing. They all must be one thing, however: they must be *inescapable*. The main character can't get away from their tormentors for very long, and they should experience a sense of dread even thinking about the next encounter.

In *Mr. Student Body President*, Tyler is surrounded by accidental tormentors: his high-maintenance constituents – in other words, every single student at the school. Lucky for him, they aren't threatening or rivalrous. They're just (in his eyes) whiny, grandiose, fickle, bossy, unreasonable and always complaining about *something*. Tyler can't escape his tormentors; in fact, he has to cooperate with them, serve them, keep them happy so they'll remain obedient. Note that they aren't just there to give Tyler a hard time; they also move the plot by throwing new obstacles in his path and forcing him to escalate his tactics, which creates rising action.

In *Brooklyn Sound*, Lucy is also surrounded by accidental tormentors: the recording artists who come to her studio. Each of them exhibits qualities that cause Lucy a lot of worry and despair. Lucy's dramatic need is to restore the studio to its former glory, to carry on its mission of nurturing budding geniuses in their formative stage. To do this, she needs clients who can pay, preferably a lot. In other words, she needs moneymakers. Instead, she finds herself working with musicians and bands who will never, ever make money. Ever. Nor are they likely to emerge as great artists of the age. These characters not only make Lucy miserable, but also raise the dramatic stakes by forcing Lucy into an increasingly desperate race against the clock

as she struggles to pay off her back rent. Jillian, in addition to being a threat, is a tormentor, leaving frequent and excessively long voice-mails, delivering her threats in a most infuriating chirpy, upbeat manner and needling Lucy with dismissive, belittling comments about the studio. She doesn't do this out of malice; she does it because she's a selfish person who thinks she's better than everyone, not just Lucy.

Perhaps the most ouch-inflicting tormentor of all (and the winner of the secondary-character antagonist triathlon) is David, who belongs to all three categories: threat, rival and tormentor. He is the worst kind: the kind who is highly motivated to make the main character miserable – maybe to make the main character fail, maybe just for the fun of it. In David's case, the motive is especially complicated. Although Chris doesn't know the reason, his dad is deliberately tormenting him as part of a master plan to force Chris to abandon emo. David never lets up; every day is a fresh hell for Chris, doomed to be constantly annoyed, provoked and outright humiliated. David employs a wide range of tactics, insulting and goading Chris, forcing him to watch as he dazzles his friends, and ultimately draining Chris' interest in emo, robbing him of his chosen identity. Even though David is doing all of this for Chris' own good, trying to help him along in the difficult process of growing up, his methods are brutal enough to make the audience cringe and pity Chris for his suffering.

Note that not all tormentor characters are *trying* to make the main character suffer out of malice. Tyler's fellow students don't particularly want to make his life harder; they're just demanding and hard to please – and there are so many of them! These are "accidental" tormentors, tormenting by their nature, not by design. Similarly, Lucy's clients have no idea what effect they're having on her, or how much stress they're creating; they too are "accidental" tormentors, just by existing. Even tormentor extraordinaire David isn't motivated by a wish for Chris to suffer, exactly; the suffering is an unfortunate byproduct of David's plan, a case of the ends justifying the means even though the means are drastic. David is not an "accidental" tormentor; he realizes the suffering he's causing, and continues to inflict it. But neither is he a tormentor at heart, obviously (though he's very good at it). He is a tormentor because his secret – and, remember, benevolent – mission demands it. Of course, we don't know this until the end of the season, but in the meantime, the audience has the pleasure of watching a father behave in ways that are unthinkable, unforgivable and certainly unforgettable.

Villain

A villain is a character who flat-out wants the main character to fail, usually with maximum humiliation and loss suffered. Thwarting the main character might be a piece of cake for the villain, a simple matter of exercising fail-proof powers, or it might take great effort and persistence in the face of frustrating initial failures. It is *always* deliberate and uncompromising; there is no such thing as an "accidental" villain. A strong villain character should have abilities that are equal or superior to the main character's, and enough power to pose a genuine threat – the greater the danger, the better the drama. The villain's reasons for working against the main character are usually malign (vengefulness, greed, megalomania or perhaps just plain old-fashioned evil), and their methods are often manipulative or otherwise dishonorable (subterfuge, deception, betrayal, trickery). A villain might love *and* hate the main character, or not hate them at all – but whatever the villain's feelings are, whether simple or complex, they work tirelessly to sabotage and harm the main character.

Sometimes audiences *like* villains, or at least have to admire them; cleverness and competence tend to impress us favorably. But we generally don't *sympathize* with them. Vice Principal Helfrick, a classic villain, is not someone we root for, nor do we feel sorry for her when Tyler puts her in her place. Occasionally a villain will be "humanized" – they might show some vulnerability, altruism or pathos that we didn't expect. However, this is often a ruse, as when Helfrick claims to like Tyler and appears to have a genuine concern for his future, not to help him but to soften him up before she goes in for the kill. A villain can only be humanized temporarily; if they switch sides and become "good," they can no longer serve the dramatic function of a villain.

Note that all threat/rival/tormentor characters are villains. The students who function as Tyler's "accidental" tormentors don't have the power or the motivation. Jillian is a powerful threat character, and a fairly nasty person, but she isn't quite malicious enough to be called a villain; she has no particular ill will toward Lucy, she's just egotistical and uncaring. David, too, falls outside the villain category. He causes Chris a great deal of stress as threat, rival and tormentor, but his motive is to be helpful; in fact, he has made significant sacrifices to benefit his son.

Also note that *not all stories have a villain*. They certainly have a *threat* character of some kind, but as we've seen, sometimes these

characters "accidentally" create problems just by being who they are, rather than being out to get anyone. Dramas that depict life in a fairly or very realistic way tend *not* to have outright villains, instead favoring antagonist characters who are more complex and relatable, and who might even be justified in their malice toward their victims. Anger and bitterness toward the main character, and a desire to see them suffer and fail, might lead a character to become a tormentor, rival or threat (or some combination thereof), but without developing a truly villainous determination to destroy the main character's chances for happiness. Extreme villains – especially ones who serve no other function in the drama and are, in their heart of hearts, 100% dedicated to thwarting the main character – crop up more often in comedies, where their single-minded maliciousness can find full expression, unhampered by human complexity.

Helper, mirror, foil

We also need to get to know the main character through interaction with non-antagonists: characters who help in the quest, listen to the main character's expressions of feelings and sometimes create complications without intending to. Sometimes these characters do double duty, serving both antagonist and non-antagonists functions in the drama; for example, you could create a character who is both a tormentor and a helper (like Pam), or a mirror and a rival. Following are descriptions of three major categories of (often) non-antagonist characters.

Foil

Foil characters exist to highlight some aspect of the main character through difference and to present a kind of commentary on the main character. Foil characters can be funny or unpleasant, friendly or hostile. The only requirement is that they create opportunities for main characters to "demonstrate" themselves: a kid brother who gets picked on at school allows the big sister character to demonstrate protectiveness, a strict or boring teacher allows the student character to demonstrate how much they hate school, a lazy waiter allows the type-A character to demonstrate their impatient and demanding nature, etc. They also let us see what's going on inside for the main character by eliciting confidences and confessions,

listening to them vent, letting them accept or reject offers of help for reasons that give us more insight, etc.

In *Mr. Student Body President*, almost every secondary character serves as a foil for the main character. By constantly questioning, criticizing and complaining about Tyler, the tormentors allow us to see who Tyler is when faced with a challenge to his authority. By showing surprise or confusion about Tyler's methods and making "helpful" suggestions, non-antagonists (primarily Tyler's staff) give him opportunities to explain himself and to respond by escalating, which shines even more light on his basic nature. This use of both antagonistic and non-antagonistic foil characters is extremely effective, granting insights into the main character under different conditions (being challenged vs. being supported).

Foil characters don't have to be friends or foes; they don't even have to be regulars on the show. Bit-part characters who only are on screen for a few seconds, never to be seen again, can help reveal a lot about the main character. A good example is the potential client with whom Lucy is on the phone in the first scene. The client isn't trying to help or harm Lucy; they're just taking advantage of a good deal. But the conversation shows us how desperate Lucy has become and how low she has to stoop to achieve her goal. Think of all characters as foil characters, no matter how minor; as long as you're giving screen time to that waitress or traffic cop or innocent bystander, why not make the scene work extra hard and use him or her to reinforce something about your main character?

Mirror

In many sitcoms and dramas that you've seen, there are characters who were clearly designed as *opposites* of the main character. It's the classic "odd couple" dynamic: two people who couldn't be more different, constantly annoying each other. Not only will the friction between these characters keep things lively, but the mirror character will illuminate the main character by acting the opposite and providing a contrast.

For example, in *Brooklyn Sound*, Lucy and Pam mirror each other; even in her overwhelmed state, Lucy is super-competent, ingenious, multi-tasking and tireless, while Pam seems to stumble through life in a kind of confused fog, struggling with basic tasks. She has her own kind of ingenuity (for example, vacuuming the

furniture by lifting the entire vacuum cleaner, not just the uphol-
stery attachment), but it's not actually productive, unlike Lucy's.
Pam's clumsiness and lack of wherewithal contrast dramatically
against Lucy's laser like focus on solving her problem, which not
only highlights each character's personality through contrast, but
also intensifies the drama: Pam isn't just a space cadet who isn't
really helpful (though she wants to be); she's actually prone to get-
ting in the way, which is the last thing Lucy needs, and a great way
to ratchet up tension in the story.

Another dramatic function of the mirror character is to teach
main characters about themselves. The main character might see
their own behavior, attitudes, values, etc., in the mirror character
and learn an important lesson. Or the main character might remain
oblivious to the similarity, while the audience fully grasps the sig-
nificance. David is a good example of a mirror character opening
a main character's eyes to their own nature or behavior. In fact,
that's exactly his plan: to show Chris how absurd and unproduc-
tive his obsession with emo is by becoming the epitome of emo
and embodying its silliest aspects. And Chris is a good example
of a main character who, at least for a time, fails to grasp the ways
in which he is acting as absurdly as his dad; his dad sees it (which
is the reason for the whole charade), and the audience sees it, but
Chris doesn't – and he can't, because as soon as he does, the story
is over (in fact, the first season ends with Chris' epiphany and self-
liberation from emo).

4

Dialog

While you've been grappling with your show premise, cast of characters and story structure, chances are that you've also been "hearing" your characters speak; in fact, your whole script might have started with an idea for a character whom you've come to know quite well, after putting them through the trials and tribulations of your story. (You might want to apologize to them for all of that.) Dialog is your most powerful tool for making sure your viewers also get to know your characters well, to understand their particularities and relate to their feelings. The words you choose – and even the number of words you use – determine whether your audience registers an important emotional nuance, or only skims the surface meaning of a scene; they make the difference between a joke that kills and a joke that flops (or goes unnoticed, which can be worse). Dialog is valuable currency in storytelling; here are some ways to make sure you're spending every word wisely.

EXPRESSING CHARACTERS' PERSONALITIES

This seems like it should be the easiest aspect of writing dialog – just write the way the person would talk. And this does often come very naturally, especially when the character has a distinctive manner or exaggerated personality trait (domineering, stupid, conceited, ditzy, etc.). But there are two pitfalls which often get overlooked: characters that feel like portraits, and characters who feel more like types than people.

Don't paint a (still) picture

It's not enough to write dialog that reveals a character's basic personality. That's a good start, but you don't have space on the page (i.e., time in the episode) for dialog that only does one job. While demonstrating who a character is, your dialog must also move the story – in other words, the words your characters speak make a clear connection between who they are and what is happening. After the setup, most of what that happens in your story should occur *because of* the character: their feelings prompt their actions, which influence other characters and bring about consequences, which in turn prompt new responses, and so on. The events of the story will only have meaning if we understand how they are rooted in character. Dialog, then, should always be on-point. If you want to show that your character is overly picky, let them complain about something – and make sure that *the act of complaining* is part of a plot point that gets us from one challenge to the next, or intensifies dramatic need. A good way to test whether your dialog is moving the story is to imagine including the line in your beat sheet. If you can't indicate dialog as an action (convinces, threatens, assures, denies, claims, vows), then you might need to go back and make it work harder.

There is no hive-mind (or voice)

When you've got a bunch of characters from different places and social backgrounds, who represent a range of ages and who have easily identifiable quirks and mannerisms, it's easy to make each one sound unique. But often, a show will be set in an environment where the characters have more in common: a workplace comedy might feature college-aged temps or burned-out middle management as the central characters; a domestic comedy might divide time between the kids and the parents. Some shows focus almost entirely on a small group of characters who are close-knit, sharing similar backgrounds and interests. The danger is that similar characters will sound too much like each other, and not stand out as individuals. It can be hard to find ways to differentiate characters when you're also trying to show that they belong together or function as a unit. Sometimes, it's fine to let a group be a group, for example Chris' friends in *Emo Dad*; we don't need Jasmine and Kyle to have highly distinct dialog styles in order to have them serve their narrative functions. And sometimes it makes sense for characters who bolster or reinforce one another to sound similar, as Tyler and Hadley often do in *Mr. Student Body President*.

Usually, though, if a character matters enough to put in the script – especially if your show, like most web series, has a small cast – they merit their own style. It can be quite tricky to preserve both individuality *and* commonality and to let your characters show contrast with each other and as they unfold as people we're getting to know. One method of dealing with this is to focus on *what your characters are saying*, rather than on their manner of saying it. This might seem counter-intuitive; when we think of someone's distinctive speaking style, it's usually their vocabulary, catch phrases and manner of delivery that we notice first. And these are all important parts of creating memorable characters. But again, your dialog has to work hard and do more than one job. Here, it must not only express individuality in terms of style, but in terms of that character's role within the drama at the series, episode and scene levels. Rather than just giving your cast of bestie characters slightly different vocabularies to differentiate them, let them *demonstrate how they are different from each other by the way they react to events*, through their wants and needs – put their personalities *into action*, and let the uniqueness come from there. *Broad City* is a good model for this. The characters Abbi and Ilana have spent nearly their entire lives together, and the style of their speech is very similar. They differ more in their personalities: Ilana is impulsive, hypersexual and crude, whereas Abbi is more reserved and, by comparison, a bit uptight. Their vocabulary differs in that Ilana swears a lot more, and Abbi speaks in denser sentences, but their differences mainly emerge in their actual behavior and the *content* of what they say, especially when they argue about each other's personalities (which is often).

PAINFULLY VERSUS BRILLIANTLY CLEAR

You might have heard of dialog that feels "on the nose." Imagine the prototypical scene of a person training a puppy not to pee on the floor. Inevitably, it happens; the response is to gently swat the puppy on the nose with a rolled up newspaper and firmly say, "No!" On-the-nose dialog is the equivalent of swatting your audience with information instead of letting it unfold through context and our understanding of the character. While it's true that scripted dialog tends to be far more concise, organized and on-point than real-life speech, the goal is to *hide* that careful crafting and shaping from the audience and to make the lines sound just as spontaneous and natural and messy as we would sound if it were us speaking.

To help mitigate on-the-nose dialog syndrome, try using subtext. Subtext is information that is suggested but not directly stated by

the text. It's the implied meaning of words, and it is a big part of how people interact with one another. Have you ever seen two people who don't like each other – frenemies, perhaps, or reluctant friends-of-friends – have a conversation? It's like a carefully orchestrated, verbal dance-fight that's all based on subtext. Nary a plain or sincere word is spoken. It's all backhanded compliments sandwiched between subtle (yet, in their impact, high-octane hurtful) jabs: "Jane! I haven't seen you in so long, it's like you just dropped off the face of the earth! I love your coat; I can never wear boxy things like that. You look so *tired*, is everything okay? I know a great aesthetician who could fix you right up." This kind of insidious needling is much more fun to witness than an ordinary sparring match (though it's also fun to cap off a round of subtextual jabs with a blatant, gleefully shouted insult).

BOX 4.1 Irony

Irony is a quality that can bring out the best and worst in your characters – often the worst! Irony exposes the difference between what someone is saying and what they actually mean, so it's a great way to demonstrate disingenuousness, deception, manipulation and outright lying.

What follows is a breakdown of the voiceover that plays over the montage in *Mr. Student Body President* "Hail to the Chief" (discussed in detail earlier in this chapter). Note that there's actually a double irony in operation. There's the voiceover juxtaposed with the party scene we're watching, for instance "You'll never win over everyone, but even your enemies can become your unwilling allies" spoken while we watch the Earth Alliance folks rejecting the beers (in environmentally unfriendly aluminum cans). And there's the juxtaposition of the voiceover with what we know about Tyler's marked lack of interest or concern regarding what students actually want (he won't meet with the band kids; he doesn't care about the homecoming game, only his pet pep-rally project). Behold:

> *You have to trust the process. We don't pretend to have all the answers, but at some point, every leader has to sit down with the opposition.*

The *opposition*? His own constituents? That's pretty disturbing.

> *It's student government's responsibility to bring everyone together toward a common goal – including those who may not always agree with our policies. To bring them to the table so they can really listen to what we have to say . . .*

(Continued)

(Continued)

Listen to what the politicians have to say? Shouldn't it be the other way around?

> *. . . even when the truth might be difficult to hear, which means sometimes we need to force our students out of their comfort zones. . . .*

"Force" people? Whose students? Tyler's grandiosity and disdain for others' free will are definitely starting to show.

> *Because at the end of the day, we're all in this together. United against oppression, censorship and illegal surveillance. If our peers can't see that, then it's up to us to persuade them. To get them to take a stand so the student body can be supported by the elected representatives of their government. A government that only exists to improve quality of life for all of us.*

No. If the students' well-being were his true concern, he wouldn't need to "persuade them" or "get them to take a stand" in favor of his regime. He is using masterful rhetoric to make unquestioning obeisance sound like liberation.

> *To help us celebrate our victories and make sure our accomplishments are well documented for prosperity.*

The saying is actually "documented for posterity," but the switch in vocabulary is deliberate, and very telling. His staff are indeed documenting for – as we will see in a later scene – their own prosperity (or at least Tyler's).

> *Sure, politics can get a little messy. Inevitably, you'll have some regrets. You'll never win over everyone, but even your enemies can become your unwilling allies.*

His "enemies," the people he professes to care about, are mere puppets – not so much "unwilling allies" as unwitting lackeys.

> *I know this is a lot to take in, so just remember this: if you stick with us, keep your head down and don't ask questions, maybe one day all this can be yours.*

And we end on Tyler surveying the scene, smiling as his constituents unknowingly play right into his hands.

Just . . . wow. Tyler has really shown his true colors here. And all of that irony is achieved while moving the plot efficiently and dramatically – that's a hard-working 80 seconds!

Subtext isn't just a tool for the passive-aggressive, though. It's also a great way to let a character's feelings come through when even they can't find words. Remember Lucy's phone call with the prospective client in *Brooklyn Sound*? She's humbling herself to a painful degree, taking pizza orders because she's so desperate for business that she has to lure clients with the promise of a free pizza party. We never hear her say, "I can't believe I have to stoop to this, I am an experienced businesswoman and music expert, and the work produced by this studio should speak for itself!" But we know that's how she feels. And the only words that hint at this are, "Yes, it [the deal] is very much too good to be true," delivered with a sorrowful half-laugh. The subtextual version so much more powerful than the on-the-nose version would have been, because it's not the fact of the situation that matters – it's Lucy's immediate, emotional experience of it.

Subtext also lets characters "investigate" situations and other characters as we watch – a brilliant way of bringing out more than one character and story elements as well. Imagine, for example, that a woman is telling her guy friend that she saw his wife cheating on him. She likely wouldn't just go out and say it, right? Instead, she might ask him casually how the relationship is going, what he was doing that weekend, etc. The audience will pick up on her meaning before he does. Or you could push the subtext even further: if the friends are having burgers, perhaps the woman compares a marriage to the relationship between a burger and the buns, and perhaps her burger/bun analogy includes a veiled reference to cheating ("You never know what the buns did to the fries before they got to the table. . . ."), and perhaps this strange, silly little conversation suddenly becomes much more serious, much more honest, sneaking up on both our characters and on us, as an audience – much more dramatic and fun than a straightforward, factual, literal discussion of marital infidelity.

BOX 4.2	Writing emotive dialog

Keep a list of common emotional/psychological states with you for a week or two whenever you're watching TV, movies, etc. Start with anxiety, depression, elation, anger and denial (or any others that you're trying to capture in your script). Whenever a character starts experiencing one of these states, *close your eyes* so you can't see the

(Continued)

(Continued)

actor's expressions or gestures. Just listen to the dialog. Note how the speech patterns shift. Does the character speak more rapidly, cramming more words into their speech? Or the opposite, slowing down and leaving blank pauses? Do they trip over words or have trouble finding them? Do they quit speaking before completing sentences? Do they start using more formal or grandiose language, perhaps to intimidate? Do they build apologies into everything they're saying? Identifying such patterns will help you write lines that express what the character is feeling, without relying entirely on having them state it outright.

YADA YADA YADA

If you listen to ordinary conversations, you'll notice that much of what you hear is unnecessary and doesn't convey any specific meaning – they're just words we plunk into our sentences to convey emphasis, uncertainty, humor, irony, etc. You'll hear a lot of sentences garnished with phrases and words such as "I don't know" and "like" (which is so, like, I don't know, ubiquitous). We rely on these conversational embellishments to help us get our point across, whether by buying us time while we search for words or by allowing our listener to intuit and help fill in what we're trying to say, which can actually bring about a deeper understanding of what we mean, you know? (See how "you know" invited you to participate in making meaning of that thought?)

These "extra" words and phrases are very useful in real-world communication. However, you aren't writing real-world communication. For one thing, you don't have *time* to let your characters indulge in a lot of unnecessary embellishment; you've got too much information to get across. Your dialog has to be not only expressive but economical, making the most of every word. And for another, in real life, we don't expect our listener to be hanging on every word we say as they perform the mental labor of taking in and processing a story – but in scripted dialog, every word is being scrutinized, subconsciously, because your audience is actively engaged in interpreting its significance. You can chat casually with your friends about whether tempura counts as a vegetable or whether you look good in beige, and they won't be struggling to discern your meaning. But

in a script, even such seemingly meaningless chatter will be "used" for something: to reveal something important about a character's personality and/or about the story in progress. Unlike real-world conversation, scripted dialog always conveys something necessary.

There's a tricky balance you must strike between writing dialog that sounds natural (similar to real-life speech) and yet is crafted for economy and clarity. The advice here is not to completely avoid conversational speech embellishments, but rather to be aware of how they *function* in scripted dialog so they can be constructive elements rather than unwanted clutter.

You'll also notice that we all convey a lot of what we want to convey through inflection, gesture and expression rather than through words; we rarely articulate the full range or depth of our thoughts and feelings in tightly crafted, crystal clear sentences. Yet this is what you must undertake in your script. Yes, the actors will bring a lot to the character, and much will be conveyed through their performance. But the actors can only deliver what they get from *you*; their understanding of the character must come from the lines you write.

DANGER AHEAD: BACKSTORY AND EXPOSITION

While you were developing your show premise and your characters, you probably also developed at least some sense of how these people got to be who they are, how their experiences shaped them and how they in turn shaped their worlds. This is useful information for a writer and worth investing time in – but also be aware that often, your audience will need to know *much less* than you do about anything that happened before the present moment (the episode we're watching). As long as we can see them thinking and feeling and reacting to what's happening "now," we probably don't need everything explained in cause-and-effect timeline form. It's a good rule of thumb to try to keep the dialog focused on the present and near future: what's happening, what the characters plan to do about it and how best to attain the goal.

On the other hand, sometimes past events are crucial for the audience to be aware of, and there's no other way to make the present moment make sense. This is the case when a current situation requires a catalyst, something to get the character moving in a particular direction.

Emo Dad contains a good example of backstory being used effectively to establish character and dramatic need, and of backstory being withheld because it isn't necessary for clarity and would only drag the focus away from the present reality. The pilot episode opens with David vlogging about his agonizing breakup, which is the *catalyst* for his descent into emo. When Chris challenges him, David "proves" that he has earned his emo-ness the hard way: through the bitter pain of rejection. The breakup is David's way of outdoing his son, who hasn't had a comparably devastating experience, and maintaining the upper hand in their ongoing conflict. In David's case, we absolutely need to hear about the breakup, and it makes narrative sense for him to reference it in dialog. In contrast, we never find out why Chris became emo, and it really doesn't matter. Lots of kids adopt such personas, aesthetics, etc. as a normal part of growing up. It actually makes better narrative sense to withhold any specific catalyst for Chris' emo-ness, because that would weaken the power differential between him and his dad: if they both had a reason, then we'd have to decide whose reason was stronger, and that could easily become a digression. It's much more effective to let David have an immediate and compelling (recent) backstory and to leave Chris fighting from a weaker position. The decision whether to include backstory or not should always come down to what best serves the drama.

Take notice if you find your characters telling their entire life story or embarking on long monologues detailing other characters' pasts. ("You've worked so hard to get over your ex, after all, you were high school sweethearts, it must have been so painful when he left you for the captain of the chess team, who had also been your best friend. . . .") Ask yourself whether *each bit* of information is necessary. If you're convinced that we need to know the facts, see if you can sprinkle them in, gracefully and unobtrusively, throughout the script rather than loading them into one awkward speech. If we don't need all of the facts, but we need some sense of how the past is influencing the present, see if you can do more with less: let us see the character sighing over a memento, or deleting a contact, or taking some action that *expresses the feeling* rather than merely explaining the facts. Information is important, but it should never commandeer your precious dialog time; consider finding other places to provide it (or experiment with leaving it out). Dialog should always lead to deeper understanding of characters and heightened emotional awareness for the audience – without being muddied or diluted with too much exposition.

LET THE LINES DO THE WORK

If you've read or written scripts before, you've probably seen parenthetical directions used in dialog. These are exactly what they sound like: an instruction to the actor about how to deliver the line, inside a set of parentheses below the name of the character speaking (see Chapter 6 for more information). It can be tempting to use parentheticals to help clarify the emotional tone or intensity of your dialog, but you actually do yourself and your script a disservice by relying on them too heavily. One danger is that you simply end up with redundant information – pestering the actor with direction, while not adding anything new to clarify or intensify the scene:

BOB: (Jubilantly) I just won the lottery!
JANE: (Sullenly) I don't see why you should get the money, I bought the ticket.

Here, the parentheticals do nothing but take up space; the lines themselves contain everything we need to know about what the character is expressing.

The second danger in using parentheticals is that you might trick yourself into thinking your dialog is conveying everything it needs to, when in fact, you've "hidden" that information in stage directions the audience will never see. Here's an example of a "mind-reading" parenthetical:

BOB: (Elated because he just won the lottery) I'm rich!

See the problem? The clue is the word "because." The parenthetical is being incorrectly used to convey plot information. As the writer, you might think you've covered the facts of the story here – Bob has won the lottery – but the audience will never get that information unless he or some other character says so (or we see the winning ticket, etc.). Other danger clues include "after" and "before":

BOB: (Elated after scratching off the winning lottery ticket) I'm rich!
JANE: (Sullen after buying the winning ticket and seeing Bob use it to win) That sucks.

In both cases, the parentheticals are either redundant if we've already seen the scratching/buying of the ticket, or mind-reading if we haven't.

Most problems with parentheticals are simply a matter of the writer using them as a crutch, rather than letting the context of the scene and the lines themselves do the heavy lifting. If you find yourself using more than one parenthetical on a page, halt! Force yourself to write the dialog without the extra directions; if you are still convinced that they're necessary, go ahead and use them. Sometimes, there really is no other way to make your meaning clear, for instance when you need a line delivered sarcastically or ironically. Most of the time, this *can* be made clear in the scene context and the line itself. But on occasion, due to other factors in the scene or regarding the character, it might not be obvious that sarcasm or irony is being used. As always, clarity is paramount; use the tools you need (judiciously).

BOX 4.3 Comic versus dramatic dialog

The main difference here is *speed*. Many actors who have worked on comedies with Woody Allen have famously told the same story: he doesn't really give too many notes, but when he does, it's usually *"go faster."* Most comedy moves at lightning speed, like a high-energy symphony. When written well, the jokes work off of one another, each building on the last, not only providing new reasons to laugh but recapturing the previous ones. This is similar to the way you structured your story for rising action: the idea is to build the laughter until peaks in a crescendo of hilarity. This is, as mentioned earlier, called *killing it*, and you want to do it in every comedic script you write.

Comedic dialog must also be *specific*. It involves exact turns of phrase, precise spans of seconds in pauses and even specific numbers of words in sentences (brevity being the soul of wit). Yet (and here's the rub), the best comedic dialog also sounds uncontrived, natural and realistic. Professional comedians refine their acts for hours upon hours; they polish and cut, they structure and build their jokes, and the result is a routine that feels like casual banter, but is, in fact, a tightly wrapped package with no joke missing its mark. The dialog in a comedy is much the same.

(Continued)

(Continued)

> Dramatic dialog, on the other hand is, well, dramatic. The rhythm and flow adjust to accommodate deeper or more complex themes. Drama is about emotion, about love, about death, and the characters take it all with a real-life, convincing seriousness. Dramatic dialog tends to be slower, except in scenes of great urgency or emotional outburst. The kind of quips and quick jabs that comedies rely on are rarer in drama. When they do occur, they are there not so much for comedic "zing" as they are for providing momentary release from increasing, accumulated tension between characters. Dialog in a drama gives us a look into the heart of our characters, so philosophizing and monologuing are suitable for the form; they are an accepted and common part of the story world. In contrast, in comedy, long blocks of dialog (especially those of the introspective, reflective sort) are often frowned upon.

HOW DO *YOU* WRITE DIALOG?

Now that you know what your dialog has to do, you get to start developing your own approach to making it happen – your own dialog-writing style. This will take time and experimentation to develop, and the more conscious you are of your process, the more fun you'll have along the way.

Find your dialog flow

Every scriptwriter develops a particular flow in dialog, and every new project might have a different flow, depending on what the project needs. Finding the natural flow of your dialog should be the first thing you start with.

Before ever opening your scriptwriting program, let the idea sit in your head for a little bit. You will no doubt have ideas for scenes, for particular moments, for character interactions – *listen* to those before you write them. Fixate on one scene idea, your favorite, the one that excites you the most, and go take a walk around the block. Play the conversation in your head, see it happening, let it play over and over again.

How does it go? Is it fast? Is it slow? Are there long pauses or is it snappy, snappy, snappy? The characters personalities and stakes of a scene will affect rhythm, so think about that – if you were in the scene, how would you react to the circumstances? Would you be nervously blabbering? Awkwardly mumbling? Once you figure out your own response, layer in the character's personality – would they react like you would? If not, what are the differences? Now, imagine this scene in a different language. Imagine your show was in Italian and you were watching it without subtitles. Forget the meaning of the words for a second – what does the scene sound like? What does it feel like? Once you've done this for a little bit and feel comfortable, vomit out the scene on paper. If it's hitting the style and feeling you want, you've got a nice sample to always refer back to, a nice starting point that will help craft the rest of your story's dialog.

Third time's the charm

Here is a three-part exercise that you can use to make fast progress from first draft through second and third. Not that this process should be rushed – sometimes a story happens on its own time, and there's not a lot the writer can do about it but keep showing up. But there's also some danger of lingering too long in the sitting-in-a-café-scribbling-notes phase. When you find yourself in the doldrums, this exercise can help you get up and running again.

Phase 1: the blurt

When you've heard the scene in your head a million times and are ready to put it on paper, do so. Ignore formatting, ignore length, ignore everything else – just let yourself blurt. Get it all on the page. Let your characters talk and yell and pause and think and do everything you think they'd do. Somewhere in there, maybe on page two or maybe on page 20, you'll start getting closer to what you're looking for, to finding your own flow and to finding the heart of the scene itself.

Phase 2: make it pretty

Now you get down to the serious business of revising. Lock yourself away somewhere without your phone and forget the rest of

the world exists. Be ruthless. Hack and chop and carve away the clutter; replace clumsy on-the-nose dialog with clever subtext; load every line with dramatic need. Get your scene in shape. Get the formatting right. Check the length; if it's too long or too short, you're not done. Read it a few times – not bad, right? Great. Now. . . .

Phase 3: rewrite from memory

That's right, *from memory*. Set that pretty script aside. Take a day or three to air out your brain. Don't work on the scene at all, even in your mind. Then sit down and write the whole thing, start to finish, purely from memory – or, more likely, from a fresh understanding of what you were trying to do. You'll find yourself writing the parts that are important enough to be kept in, while anything not necessary to the story will naturally drop away – sparing you some agonizing decisions about when to "kill your darlings." And you can do this freely, resting assured that you aren't losing anything; you can always come back to the "pretty" version and reborrow bits that you decide to keep.

There is always a chance that, after all of this work, this scene won't even be in the script. Once you write the entire episode, you may look back at this and think, *Yikes, this doesn't fit at all with what I was writing*. But that's fine – what you've created is a sample of your own style, a piece of writing you can always reference and reflect on, that can help you find your way when you've lost it. If done well, this scene is your north star, constantly guiding you in the right direction so that, even if it's never seen in the final product, the lessons learned while writing it will be apparent in all the episodes thereafter.

5

Writing and revising

Perhaps this chapter should be called "Writing and Revising and Revising and Revising," because as you've no doubt heard said, there is no great writing, only great rewriting. Even so, from the very first moment you sit down to write, you'll want to have a clear sense of what you're trying get on the page – you need a *plan*.

ORGANIZING THE STORY

Start by plotting a bare-bones graph of your story. In the setup area on the left side, list your character (not just their name; indicate what traits they have that will come into play and make the goal more urgent or harder to reach); the crisis or disruption of the status quo (which is *specific to this episode*); and, in one short sentence, their dramatic need (which includes the external and internal central questions). If you plan to have a B-story, make a separate graph for that and focus first on the A-story. Add the three stars, or challenges, making sure they go from bad to worse. At the top of the graph, write the *event* that constitutes a Death Star moment: the call from the landlord, the sudden appearance of an even stronger antagonist, etc. Note that the character making a decision, changing their mind about what they want, or doing anything else internal, is a *response* to something, not a challenge in itself. The peak moment needs to be something we can see happening.

Once you have the basic structure worked out, you can start fleshing out the story. It's one thing to name the crisis, dramatic

need, Death Star moment, etc. It's quite another to figure out how you're going to show it all: what will we see characters do, what will we hear them say, what twists and turns will happen – in short, what are you going to put on the page?

One very useful tool for this is the beat sheet, which is basically a list of important plot points. Most of these will be external events (new characters entering the fray, problem-solving attempts backfiring) or internal processes *made explicit through action or dialog*. You should be able to list each beat in a short, declarative sentence indicating an action. Here is a beat sheet for "Hail to the Chief":

- Walk-and-talk with staff: Tyler learns that Principal Helfrick opposes his plan to have indoor fireworks at the pep rally he is planning.
- VP suggests Tyler change the theme to appease Helfrick.
- Tyler rejects suggestion (would make him "look weak"), states intention to confront Helfrick and refuse compromise.
- Tyler tries to flatter Helfrick, but she forces him to compromise on the length of the assembly.
- Tyler learns that the school's star football player has been suspended for drinking at a party (which Helfrick learned about via a picture of him on Instagram), as have many other important students, endangering the pep rally.
- Tyler proposes a moratorium on Natalie Vrendenburgh's much-anticipated birthday party to avoid further suspensions.
- Tyler's staff threatens mutiny.
- Tyler faces crowds of students outraged about being suspended, demanding that he fix the problem.
- Tyler claims right to grant presidential pardons, but Helfrick claims her hands are tied regarding the school's code of conduct.
- Tyler sees popular student live-streaming her own suspension.
- Tyler confronts Helfrick for suspending the homecoming queen.
- Helfrick challenges Tyler's belief that high school matters and warns him that his constituents have no faith in his leadership or his concern for their well-being.
- Natalie accuses Tyler of sabotaging her party.

- Tyler convinces student groups that it is everyone's interest to make the party happen.
- Tyler's staff take incriminating photos (some staged) of students drinking, passing a bong, etc.
- Tyler reveals that he is only manipulating the students to further his agenda.
- Tyler successfully refutes Helfrick's claim that high school doesn't matter, uses pictures of "good" students and evidence of her discriminatory policy to blackmail Helfrick into signing off on the fireworks for the pep rally.
- Pep rally is a huge success, including fireworks.
- Helfrick vows to make war with Tyler.

Note that the beat sheet is extremely sparse compared to the lengthy analysis given above. The smash cut to school staff discussing the decision to "just suspend" students even though the staff can't understand anything they say on social media is not mentioned. There is no indication that the party will be shown as a montage, or that Tyler's deviousness is conveyed via a voiceover. Elements are not labeled according to dramatic function (Death Star moment, second act complication, etc.). The beat sheet is strictly a list of *what has to happen* in the story. There is no dialog, even the best zingers; if a character says something important to the plot, it is indicated as an action: suggests, proposes, claims, accuses, convinces, reveals, refutes, vows. Everything on it is something we can see or hear. Complex scenes are listed as simple events; you might expect Helfrick's discouraging speech to be described in great detail because it is a pivotal scene that provides a penetrating look into Tyler's soul, but the fact is that very little *happens* in terms of action. The beat sheet is not the place to describe characters, dramatic need, the tone of scenes, production issues (montage, voiceover, slow- or fast-motion). Just write the very basics of what we need in order for the plot to make sense.

IDENTIFYING THE GOAL OF EACH ELEMENT

Because you're trying to handle so many things in the generating phase of writing – so much to think about, so many decisions to make – it's easy to lose track of what you've got. As you go along, keep asking yourself whether each part of the script is not only

doing its job, but doing it in a compelling and believable way. Audiences can tell when story elements are plugged into a formula or when someone does something out of character just to solve a problem with the plot's logic. It's not enough that your beats move us from point A to point B; they have to have *energy*. The following sections will help you assess what's actually on the page.

Does the setup open with a bang?

The first scene in any script is incredibly important, but even more so in a web series, because your audience is accustomed to giving shows a quick glance before clicking away (especially those they're watching online, with a million other tabs open and a phone in one hand) unless something immediately draws them in and hooks them. "Josiah and the Teeth" opens with the spectacle of an extremely strange collection of characters about to do something cringeworthy, or possibly amazing – generating curiosity and suspense. "Hail to the Chief" opens with a dramatic, fast-paced scene in which we meet a compelling (to say the least) character already engaged in a do-or-die conflict with a powerful adversary.

Does your first page (or minute) provide a similar hook? Does it kick off an intriguing, engaging story? Does it attract viewers to the characters and immerse them in the story world? Does it introduce the themes and the central question of the show? Does it give us a strong sense of the show's style? Have you put anything in that won't get resolved by the end? (You may have heard of the Chekhov's Gun rule: if you show a gun in the first act, it must get fired by the end of the story.) Do you see anything in your first few pages that are likely to end up as loose threads at the conclusion?

Does Act I feel like a story?

After you've set up your story, the first act is the foundation for the rest of the script. Without it, the whole house topples. Ask yourself whether you have elaborated upon every problem introduced in the setup and, if necessary, planted the seeds of the B-story, C-story, etc. Ask yourself:

- Does every character continue do demonstrate his or her quirks, limitations and other personality traits?

- Does every character express his or her dramatic need or goal for that episode?
- Have you used the dialog and action to foreshadow the ongoing development of the characters and the complications/climax of the episode?

Does Act II drive the story forward?

The second act is the journey, the heart of the story. It's where our characters deal with their problems and either defeat them or sink deeper into them. It needs to include two crucial plot points of the story: the protagonist's failure to achieve his or her goal, and the one desperate, last-ditch effort to make everything work out (both internally and externally). The action should be leading us toward the ever-important second turning point and the stakes should be raised higher and higher. It also needs to connect to Act I. Ask yourself:

- Are you developing every plot point that you introduced in Act I?
- Is everything you mentioned in Act I, every seed of every plot point, joke or character trait that's relevant to the story, further developed in Act II?
- Do the story and all of the character's actions and motivations make sense, thus far?
- Does Act II lead us energetically and inevitably into the climax of Act III?
- Most of all, ask yourself: is it entertaining? (A question you should be asking yourself throughout the process.)

Does Act III pay off?

Act III is where everything comes together, the culmination of every plot point introduced in those first few pages, the climax of your entire episode. Act III needs to tie up every loose end. Check this by asking yourself:

- Does it use every joke, every character trait, every wayward comment made throughout the script (preferably in Act I) to lead our characters to the climax and help them past it?

- Is it exciting?
- Does it end in a satisfactory way, with both the characters and the story staying consistent with the rest of the acts?
- Is the conclusion – usually the last few pages – strong?
- Does the story and all of the character's actions and motivations make sense, thus far?
- Does it make us want to watch the next episode again, once the credits roll?

Once you're pretty sure you can say yes to all of these questions, brace yourself: it's time to get feedback so you can write (cue celestial choir) the next draft.

THE IMPORTANCE OF FEEDBACK

Some advice about drafts: expect to write a lot of them! And every time you write a new version, *get feedback*.

Writers can't really know what's on the page until readers reflect back to them what they're learning as the story moves along. *You* know everything about the character, their motivation, why one event leads to another, but there is a yawning chasm between your mind and your viewers'. As writers, we tend to assume that other people share our attitudes and beliefs, aesthetic taste, expectations of how cause and effect work and the "logic" of emotions into our work. This is good because it gives the work voice and individuality – but it's also problematic because viewers have their own ideas about how the world works and why people are the way they are, based on their individual life experiences.

Often, even when you think you've made everything clear and explicit, you'll find you've made assumptions about how characters will be perceived and how scenes will be interpreted. You might intend a character to be perceived as wry or sassy, while your viewers might find the character cruel or narcissistic. What you think of as a serious power struggle might be read as friendly competition, or flirting, or characters just being their snarky selves. Keep in mind that your audience isn't psychic; they don't know what you intend, only what you write – no mind-reading! If you want the audience to grasp a character's motivations, or to understand the significance of a scene, you have to make sure it gets demonstrated through action or articulated in dialog.

As if that weren't enough to worry about, scriptwriters also work in an audio-visual medium, which means that the words on the page read one way but sound another when spoken out loud or translated into a visual scene. What you hear and see in your mind is going to get filtered through a lot of other ears and eyes, and in that process, you'll find that the plot point you thought you'd nailed is actually confusing to the audience, or the joke you thought was the best part of the script falls flat.

In order to bridge this gap between your mind and your viewers', you need feedback that tells you what you have actually put on the page (as opposed to what you think you put there). Writing in a void, without checking how clearly your audience understands the story, can be frustrating and demoralizing. Instead of trying to find your way in the dark, hoping that you're being clear, *check in*. You can ask your friends and family to be readers, but keep in mind that, because they know you, they too might project some inside knowledge – they'll "get" your sense of humor while readers who don't know you might not; if they've listened to you talk about the script, they might not be objective or able to read without projecting what they know you're trying to do. It's also possible that they'll try to spare your feelings and offer only praise. You might have to work hard to convince them that you really, really want their honest opinion.

To help them think analytically, give them specific questions such as these:

- What does the character want?
- What is the character worried about if they fail?
- Why are the antagonists trying to thwart the character?
- What's the worst thing that happens to the character?
- Is anything about the story unclear?

Still, it's useful to have non-scriptwriters read, because they'll be able to respond as viewers rather than as script-doctors or analysts (or writing teachers). If you know anyone who does improv, sketch comedy or theater, or who writes prose fiction, ask them for feedback and consult with them about how they approach crafting stories. In addition, many competitions include feedback from judges. If you're a student, you can ask professors to read your work; they might be too busy to read scripts from people who aren't currently in their classes, but it never hurts to ask (do this in person – you're

asking for a considerable chunk of their time, so you should be willing to invest effort beyond sending an email).

It's important to also get feedback from people who are familiar with the craft. There are several ways to make this happen: the workshop, the staged reading and the table reading.

The workshop

The writer's workshop is a great way to get another writer's critical eye on your script. Your scriptwriting class might have workshops built in, or you can form or find a group of like-minded individuals and gather somewhere – preferably a place with a lot of coffee – and you read one another's work as critically as possible, giving written and/or verbal notes, reflecting back to the writer what you "see and hear" as you read the script.

Many workshops are led by a professional (a teacher, or a writer who also leads workshops) who knows story structure and is familiar with the most common difficulties encountered by new-ish writers. Even if you don't have access to such a facilitator, it's easy enough to find fellow writers in your classes and in the community. At the very least, a writer's group will push you to let someone besides yourself read the script and give you an honest response to it; and ideally, you'll have several talented writers who see the things you don't see and suggest small changes that help galvanize your script and make it go from good to great. Either way, the writing workshop is the first step to writing a good third (and fourth, and fifth) draft.

A note on giving good workshop feedback: saying you "like" something is not helpful. Saying you "don't like" something isn't helpful, either. "Like" isn't a word that should come up in a workshop. In fact, aesthetic taste should be checked at the door. Your job as a workshop partner is to read closely and *analytically* and to apply what you know about story structure, character development, etc. You don't want to make anyone feel bad, and no one wants to make you feel bad, either; but you won't be helping each other if you don't dig in and do the work.

Staged readings

A staged reading is exactly what it sounds like: you appoint your classmates, or enlist actors (the most capable ones you can find), and

have them act out your show in front of the class or on a stage in front of an audience which will share their thoughts on the script afterward. Regardless of what you manage to put together and where and with whom, the reading is a *necessary* part of the editing process. While getting input from other writers in a workshop is great, they're still not *hearing* and *seeing* the story – which means many "flaws" won't be apparent. The live performance can make all the difference.

An important aspect to the reading is to get good actors and to have a few rehearsals with them before doing the reading in front of the audience. It doesn't necessarily matter whether the actors at the table reading are the actors who will eventually play the roles (though that would be ideal). However, it is important that the actors are skilled. The problem with *hearing* the story is that if the actors don't do the words justice, it can make the script sound bad and create flaws that wouldn't be there had you a better group of actors performing. Talk to them, work with them, get them to refine the timing and the voices of the characters – once you're ready, get them in front of an audience and see the magic happen.

A staged reading might not involve performing all of the stage directions fully (especially when they call for fighting, sex, car chases, etc.), but it's helpful if the performers can work in *some* gesture and movement to help the audience better envision your story.

The reading should end with a talk-back, where the audience tells you what they thought of the whole thing. Take notes, listen and don't get defensive. Even if the response is lukewarm or even negative, it's better to hear it *now* instead of *later*, when you've already invested a tremendous amount of time and energy into refining (and maybe even producing) the episodes.

A reading is especially important for web series because it not only helps you craft a strong story (something that is sorely lacking in the online-entertainment space), but it also lets you witness a live audience response, something just can't get from posting your video on YouTube.

Table readings

You've written and rewritten, you've heard it, you've seen it, you've gotten a ton of wanted and unwanted criticism and now it's finished – you've cast it and are ready to shoot. Right? *Almost.* The final step of making your script pretty is the table read – where you,

the director, possibly a producer or two and the entire cast sit down and read your script out loud.

The table reading is not "just another" staged reading. In a table reading, the people who are actually going to bring the script to life are the ones you get to see and hear, and you will find that some tweaking is desirable here and there. In fact, you should expect your "final" script to change fairly significantly during the table reading – not its structure, but its nuances and finer points, especially in dialog. No matter how good the actors (or classmates) you got for your reading were, you now have an official and probably different cast. Actors have different ways of talking, of interpreting scenes and delivering lines and of displaying emotions. As a result, the lines you thought worked before may not work now. Furthermore, you may get ideas for moments that work *specifically* with one of your actors that wouldn't have been possible before you had the final cast. And the actors themselves might (correction: nearly always will) offer variations, riffs and ad-libbed dialog that makes you cry, "Someone write that down!"

The table reading also gives the director, cinematographer and other key crew members a chance to really visualize and get a feel for your story. If artistic differences are going to emerge, it's good to have a chance to talk about them before you're on location. It's also better for the director et al. to ask questions, and for you to think through possible answers, now rather than on-set when time is a precious commodity. A lot can happen during the table reading: an actor may have a different idea about how to play a character; the director might want to change a location or a motivation; it might emerge that one or more parties are confused about a line of dialog or a plot point. The sooner you can deal with these issues, the better.

BOX 5.1 **Sifting through the critiques**

Once your script is finished, it stops being your baby and joins a much bigger family. The actors and crew will bring their own thoughts, quirks and individual flavor to your writing. It is important then, to know how to take feedback – when to listen, when to ask more questions, when to oblige and even when to indulge in being a "difficult" writer. The world will often see fit to give you its wanted or unwanted opinion. As a writer, your job is to know when to listen and when to fight.

(Continued)

(Continued)

> Sometimes, the problem is obvious. Sometimes, a note will just feel *right*. Other times, you'll notice a criticism will keep popping up no matter who you give the script to. A good rule of thumb is, if several readers mention it, you should at least take a look with an open mind; something isn't landing quite right, and even if the reader isn't spot-on about why, you'll probably find an opportunity to clarify or strengthen.
>
> You'll also often get contradictory notes. In these situations, ask yourself, "Who are the note-givers?" If you trust the reader and/or it's a director you chose to help you with your series, or a producer who is running the show, then it's in your best interest to hear them out. On the other hand, some people like to comment on everything – you know those friends, the ones who will loudly explain why every film isn't good enough. They may not be trustworthy and, for whatever reason, may just be unable to plainly say, "I like it."

REVISING

No great script was written in one go, which is comforting to know when you've finished your script but have a nagging feeling that it needs more work. It does. You should expect to write several drafts, but don't think of this as failing the first time; a better way of putting it might be "you will have the opportunity to keep working on the script." After setting it aside for a bit so your creative mind can rest and get some distance, come back to it with fresh eyes and a bold heart. As the saying goes, there is no great writing – only great revising.

Trimming the fat

Early drafts tend to be bloated with extraneous material – characters, scenes, even the number of words being used – because the writer is in the *generative* phase of making sure that everything is clear and nothing is missing. It feels instinctively safer to get it all out there than it is to leave anything out, which is perfectly fine. This is the time to indulge and "blurt" everything you can think of without worrying about what will disappear later. In this phase, writers tend to overdo things; we want every nuance to be felt, every detail to stick in the viewers' minds, every character to be understood and loved (or hated). These are all excellent goals.

Here's the catch: your audience might need *less*, not more. As you get feedback, you'll see where your audience needs a strong guiding hand, and when you can place more trust in their imaginations, their willingness to suspend disbelief, their ability to respond to emotional fluctuations, their comprehension of plot and story arc. You want everything to be clear to your viewers, but you also want to avoid trying their patience with a lot of repetition and extraneous information. By clearing away the clutter, you create more room: to rethink, to rewrite, to see what's really important and give it more weight.

So, your job is to *trim the fat*. At the macro level, this could mean dialog that doesn't move the story or develop character (or, preferably, both), an "orphaned" a plot point that never gets wrapped up, even full scenes that seemed pivotal in the early stages of writing but which you now must admit no longer work with the story. At the micro level, it means distracting and confusing clutter. You can prune your script quite easily if you stay alert for the following pitfalls.

Stage business

There are various styles for writing action. Some writers invest a lot of time (and page-space) in crafting vivid, poetic or blow-by-blow descriptions. Others provide the minimal information required for the reader and/or director to get what they need to understand the scene.

Compare these scene descriptions: "Looking wildly about him, Bob spots a vicious-looking rat. He gags, struggles to collect his wits and draws his gun" versus "Bob sees rat, draws gun."

The first is fun to read and provides a good deal of mood and visual detail; it helps everyone "sink in" to the mood and feel of the scene. It would work wonderfully in a short story or novel. The potential problem, though, is that it is all too easy to get bogged down in description that doesn't help the reader do what they need to do. But the second example is more suited to scriptwriting because it allows the reader to find and focus on the *necessary* information, and fast. No one is reading a script to enjoy savoring the beautiful language (sorry, poets!) – they are reading in order to make sense of the characters and the story. The shorter version will

actually go further toward creating clear images in your readers' imaginations.

Another danger is that there will simply be too many lines of action on the page. There is a standard for the page-to-minute relationship. TV scripts time out to a consistent number of minutes per page (usually 30 or 60 seconds). This is important when, for instance, a two-page scene gets cut. How will the director know whether they just lost 30 seconds or 4 minutes? This is why simple, clear scene descriptions are generally best. They don't have to be sterile or bare-bones, but they should be free of distracting or over-whelming verbiage.

Whether your style is extremely bare-bones and minimalist or a little more on the let-me-paint-you-a-picture side, the action should be written in short, staccato beats with plenty of paragraph breaks. Writing your action in long, dense blocks will this make your reader skip over much of what you wrote, which means you risk losing clarity. (It will also make many people whose job it is to read scripts all day really hate their jobs.) Keep it simple, direct and to the point.

Clutter words

As a scriptwriter, you want to be *economical*, which means that every word is helping by giving necessary information. If a word or phrase isn't helping, then it is actually hurting by clogging up the page (and the reader's brain). Here are a few common forms of clutter that are easy to find.

Adjectives

If you're describing a character's "long, curved, cherry-red-painted claw-like false fingernails," that's clutter. And, unless every single one of those details is "non-negotiable," you're intruding on the makeup and wardrobe department's job. Instead, give only as much description as it takes to communicate a basic idea of the character: maybe she just has "tacky" or "scary" nails, "nails like claws." Or maybe her nails don't matter, and you really mean that the character is vampy or dangerous. In

that case, leave the detail out; you're drawing unnecessary attention to the nails themselves, and possibly failing to capture the overall effect.

Adverbs

If you write, "Bob slowly turns carefully and deliberately, drawing his gun silently and grimly, stealthily sneaking up behind his rival," you've got clutter. You're also directing the actor, which is not ultimately your job. Stick to the basic movements needed for the scene: "Bob turns and draws his gun." When the scene calls for more nuance, give it – remember that every word you spend is precious. You might be surprised by how much page-space you can save by avoiding these frequently unnecessary, redundant or misleading words:

- *Quickly:* "He quickly runs." "He quickly ducks." Is there a non-quick way to do these things? However, if someone does something quickly because they are trying not to get caught doing whatever they're doing, you would write "She quickly hides the gun behind her back." Or you could go for something more expressive, such as "guiltily" or "deftly."
- *Very:* This doesn't do a good job of conveying degree. Instead of "very happy," use a more illustrative word such as "elated" or "ecstatic."
- *Suddenly:* Like "quickly," this should only be used when the action needs to happen unexpectedly. It should not be used simply to emphasize the importance of an action; that should be clear from context.

In conversation, when we aren't under pressure to keep our speech tightly crafted and zero-waste, we often plunk in or tack on words that aren't strictly necessary. Those word and phrases *might* be OK in dialog (but probably not), and they shouldn't be in scene descriptions at all. Here are a few that pop up all the time:

- *Then:* Everything you describe is understood as happening in chronological order (the order in which it appears in the script). The "then" in "He barges into the room, then sees the dead body on the floor" is unnecessary.

- *Starts to:* "Bob starts to go to the door." "Sally starts to pour the tea." What are we seeing, exactly? Do we see Bob go to the door? Do we see Sally pour the tea? If so, then "starts to" is clutter. However, if Bob is suddenly stopped in his tracks, and doesn't make it to the door, or if Sally drops dead before she can actually pour the tea, then "starting" is in fact all we see, and the scene should be written as such: "Sally starts to pour the tea, but drops dead, still clutching the teapot."
- *Over:* "Bob walks over to the fridge." The word "over" contributes nothing to the sentence, so it's clutter. Lose it: "Bob walks to the fridge." See how omitting just one word keeps the line clean?
- *There:* Sally stands there in her pajamas." Or: "Bob stands there, confused." Where is "there"? It can only be in the location where the scene is taking place, right? No useful information is being added by word "there," so leave it out.
- *On [his/her] face:* "Bob turns with a grin on his face." Can a grin, or any other facial expression, be anywhere besides on a face? Similarly, writing about "facial expressions" is redundant: "Sally's facial expression shows amusement." Stick with "Bob turns, grinning" and "Sally looks amused."

Mind-reading

Never write anything that we wouldn't see or hear if we were watching the scene. For instance, don't write, "Marsha doubts that Jim is telling the truth" unless you've set up the story so that we understand what she's thinking – and we can't know that unless she does or says something to reveal it. In fact, your tools as a writer are very similar to the tools an actor can use: you can only show the emotion or subtext of a scene through the characters' expressions, gestures, actions and dialog. If Marsha responds skeptically to Jim, or rolls her eyes, we can see and hear her emotional state. A "mind-reading" line in the script will not accomplish the goal.

The same rule goes for using parentheticals in dialog (also discussed in Chapter 4). Parentheticals are used to indicate something

that affects the delivery of the line and that wouldn't be clear otherwise: choking, whispering, etc. They can also indicate how a line should be delivered, for example when a character is speaking sarcastically or fearfully. Ideally, however, the story context and the lines themselves should tell us everything we need to know. If you find yourself using a lot of parentheticals to direct actors or explain how a character is feeling, beware: you might be using them as a crutch and tricking yourself into thinking that the emotion of a scene is clear, when actually it isn't being communicated effectively to the audience. Most good dialog requires no parentheticals at all; challenge yourself to write your story and your scenes so clearly that the actors won't need any parentheticals because there's no other way to interpret the lines.

Camera-talk

It can be tempting to "direct" every scene in your script by describing camera position and movement, lenses and filters used, etc. Resist this temptation. There will be times when you need, say, a montage or a reaction shot, and that's fine – but check Chapter 6 for advice about using these.

THE FINISHING TOUCH

Proofread. Then proofread. Then proofread again. You are a writer; you are responsible for mastering all the tools of your craft, including grammar and punctuation. You might figure that your reader won't get hopelessly confused if they come across a misspelled word or a missing comma, and that might be true – though this can happen a lot more easily than you'd think! See the Writing Mechanics Guide in Appendix B for examples of how incorrect punctuation can seriously derail the reader (and create embarrassing "alternate" readings, much like auto-correct incidents). One of every dialog-writer's worst foes is the missing comma with direct address. Behold: "Let's eat, Grandpa!" versus "Let's eat Grandpa!" Such is the power of the mighty comma. Every time you let this kind of error slip by, no matter how minor it seems, you're doing a disservice to your work by marring the pristine clarity of your writing.

BOX 5.2	Make it happen

Binge was always a product of love. When Angela Gulner came to me with this story, it was so powerful, so dark and surprisingly funny, I knew we had to make it. Angela and I wrote the script together and then proceeded to pitch it around Los Angeles. The responses were lukewarm – we had wanted Angela to star in it, and since she wasn't famous, it gave people a reason to say "no." Add to that the fact that it was a dark, female-driven comedy about bulimia and that Hollywood is famously risk averse, and we quickly realized that selling *Binge* was going to be an uphill battle.

We decided to shoot it ourselves instead. We have a production company, so we were lucky enough to have not only access to film gear but also to a few amazing crew guys who pledged their free time to help us make the pilot. Angela and I rewrote the original pilot script that was a bit too *big* for self-funding (specifically, the locations were too many and the end featured a big wedding), and we jumped into shooting. We filmed for 5 very long days with a crew of 4 to 5 people max (sometimes less). It was a slog, with the longest day stretching into around 16 hours, with us wrapping at 4 a.m.

We cut the pilot in-house (we have the luxury of having one of our co-owners, Dashiell Reinhardt, being a fantastic editor, and another one, Justin Morrison, being an amazing Director of Photography) and felt like we had something special on our hands.

This time, instead of pitching it around town, we figured – let's throw it up on YouTube and see what happens. At worst, no one watches it and we delete it. At best (we thought), we'll get a couple thousand views and some nice quotes to throw in a pitch deck.

We did have a marketing plan, though, which is highly important – if no one sees what you release, then you may as well not release it.

Our plan was a very simple one: (a) release after Thanksgiving, which is a really rough time for people suffering from eating disorders, (b) contact press around 3 weeks before the launch to show them the pilot and beg for a feature on the day of the release and (c) write your own articles to get published on sites that hit the community you're targeting (for us, female-centric was always the way to go).

When we released the episode, multiple outlets also released their articles on it, and suddenly, the show was everywhere. It started getting linked all over the web, and our views starting flying up – from launch to Christmas, we had already passed over 200,000 views. It was . . . intense.

(Continued)

(Continued)

Our failure came when we decided to try and pitch it after that. While we got a lot of great meetings with major networks, people still were afraid of the subject matter. After a year of getting close and having deals fall through, we decided we had to go back to the original plan: make this ourselves.

We decided to use IndieGoGo instead of Kickstarter (it lets you keep any money you raise, while Kickstarter will return all the money if you don't hit your goal) and set a very low goal of $35,000 with the hope of bypassing it and raising higher amounts.

Crowdfunding is an incredibly difficult thing. It's like running for office. For months beforehand, we prepared. We shot reward videos. We emailed hundreds of people asking for them to pledge to donate in the future, when the campaign launches. We attended events (including getting into the Independent TV Festival in Manchester, Vermont, and winning Best Actress for Angela!). We peppered the internet. When it launched, we had a similar plan as the launch of the pilot – get press ready for the release and try and space it out over of the 5 weeks the campaign runs.

In the first 4 days, the campaign had already gotten to almost 70% of its goal. The reason? Aside from the marketing, people want to support projects that help the world, that give voice to the voiceless. The campaign was a huge success and not only monetarily – it brought with it investor interest, sponsor interest and meetings galore. Nothing helps sell the show like a passionate audience.

Despite all that, the amount raised is barely enough to shoot one episode, let alone a full five episodes at 22+ minutes each. At the time of this writing, we're still knee-deep in the crowdfunding campaign, and the plan remains the same: get the money, call in a lot of favors and shoot the season over the course of the year, using the money to pay for food, locations and some "thank you" fees for our dedicated, amazing crew.

The lesson here is one I've had to learn over and over and over again: wait for no one. Make what you believe in. That's how my career started, that's how I've advanced it, that's how I'm going to continue growing it. Make your vision – because if you're too afraid to take a risk on it, why would someone else?

– Yuri

6

Format

An incorrectly or sloppily formatted script makes a terrible first impression – and writers don't always get a chance for a second one. Fortunately, there are many script formatting apps available for purchase, download or use straight to and from the cloud. The ones that have been around the longest, and that have become fairly standard in the industry, are Final Draft, Amazon Storywriter and Celtx. If you check them out, you'll notice that the scripts all come out looking just about the same. This is no accident. Script formatting has evolved to make everyone's job easier: the actors looking for their first lines in the script, the set designers and propmasters who need to know what to have on hand, the director and DP composing shots. Everyone involved in a production has a specific role, and the script is the only thing holding it all together. If you aren't putting the right information in the right place, you aren't fulfilling your duty as the writer.

When you look at a script, you'll see three major elements: the heading (or slugline), the action (or scene description) and dialog.

SLUGLINES/SCENE HEADINGS

Every scene gets its own scene heading, usually a slugline (some types of sequences, such as special angles and talking head interviews, get a different kind of scene heading and will be discussed later in this chapter under "Camera Directions and Special Shots"). This means that any time there is a cut or other transition to a new scene, or the location changes (even a little bit), you need a new slugline. Get used to writing them! It can start to feel repetitive, especially

when you've used a location numerous times in your script, but like all elements of format, there is a reason for using a slugline every time. Readers should be able to flip through the script and know whether the crew will need to set up for indoor or outdoor shooting; identify every instance of a location being used (and therefore lit, furnished, dressed, etc.); and know how to indicate the time of day, or passage of time, within the story. Therefore, sluglines give these three crucial bits of information, each of which deserves a closer look.

Interior (INT.) or Exterior (EXT.)

This is basically what it sounds like: whether we're indoors or out-of-doors. "We," in this case, actually means "the camera." Here are some examples in action:

INT. HOUSE – LIVING ROOM – NIGHT

Note that this example includes "INT." because the scene takes place inside a house. Whether a shot is interior or exterior depends on where the camera is. For instance, if we saw the bushes and front door of the house, the slugline would say "EXT." (and probably "FRONT PORCH" instead of "LIVING ROOM").

This can get a bit confusing when it comes to locations that could be inside or outside, like cars. If you have a shot of characters in a car, are we (the viewers) "in the car" with the characters, or do we see the outside the car? *If we see the outside of the car*, we know for sure we are *not* "INT. CAR." But that doesn't *necessarily* mean we're "EXT. CAR." If we're seeing the car in a driveway, we're EXT. DRIVEWAY. If we see the car in a garage, we're INT. GARAGE. All that matters with INT. and EXT. is whether the camera is inside or outside – don't worry about what what's being shown yet (that's coming up soon enough).

Location

Next comes the location and, if applicable, sub-locations indicated with a dash:

INT. HOUSE – BOB'S BEDROOM – DAY
EXT. SAN FRANCISCO – LOMBARD STREET – NIGHT
INT. CAR – BACKSEAT – DAY

It is extremely important to always indicate locations the same way. For instance, you would never write INT. BOB'S HOUSE – CLOSET – DAY in one scene and later call it INT. BOB'S PENT-HOUSE SUITE – WALK-IN CLOSET – DAY. That would cause the production team to think there were two locations they needed to use, when really there is only one.

Time/passage of time

The final element gives either the time of day or an indication of how much time is passing between scenes. This can be important both for lighting scenes and for keeping flow and continuity as the story moves along. Usually, this information will appear simply as DAY or NIGHT. This is crucial information that lets the production team know they will need to use a location both during the day and at night (important for scheduling, permits, etc.); it lets the lighting crew know that they will need to prepare for both day and night scenes within one location (maybe on the same day). The set dressers might also need to know so they can make an apartment look like it's morning and someone has just left, or like it's evening and someone has just come home.

Sometimes in scripts you will see more specific time elements given, such as DAWN or DUSK. This can be useful for lighting that establishes mood or very specific times of day when necessary, but be careful – easy for writers to "trick" themselves into thinking they have communicated something, when in fact only the people who see the slugline will ever know. For instance, if the writer puts INT. BOB'S BEDROOM – 6:30 A.M., how is the audience is going to know what time it's supposed to be? *The audience never sees the slugline.* The writer needs to put the "6:30 a.m." information somewhere we can see or hear it, perhaps via a clock showing the time or someone saying it.

If your story takes place over more than one day or night, you can indicate this with sluglines written as DAY ONE, DAY TWO, etc. You might also see a night scene followed by NEXT MORNING. These can be good cues to the production team, again for purposes of lighting, wardrobe and makeup and dressing the sets. Just bear in mind that the audience does not see the sluglines, so whatever you use as your "time-telling" element will need to be something you can show.

Another option for the third slugline element is "CONTIN-UOUS." Use this when your character(s) move through different

locations but do not interrupt their action or conversation. Example: if your characters are having a walk-and-talk, and they travel from an office to a lobby to an elevator, that's three locations – and three sluglines! – but the action is uninterrupted, so the final element in the slugline is "CONTINUOUS." You can also use this to connect a sequence of quick cuts during which no time passes, or a sequence that combines talking head interviews with regular scenes; you'll see several of these in the sample script (*Brooklyn Sound*, "Josiah and the Teeth") in Appendix A.

Note: *Never* add information beyond INT./EXT., location and time in your slugline. There must be no action, no dialog, no scene description – *nothing* but the three basic elements. Here are some examples of what *not* to do in a slugline:

- INT. RESTAURANT – WAITRESS SERVING COFFEE – DAY. Clearly, the "waitress serving coffee" is not a location; it belongs in the next element we'll discuss, the scene description (action).
- EXT. CENTRAL PARK – JOGGERS – DAY. Again, "joggers" are not a location. You could write "JOGGING PATH" instead and then, in the scene description, indicate that people are jogging by.
- EXT. BASEBALL GAME – CHEERING CROWD – DAY. This one almost makes sense, but there are a few problems. A "game" is not a location; a "stadium" is, or a "high school baseball diamond." Likewise, a "cheering crowd" is not a location, but you could say "bleachers" or "stands." If you write "cheering crowd" as the location, does that mean that the camera is down on the field pointing up into the crowd? Or does it mean the camera is "sitting next to" someone in the bleachers? Remember, your sluglines do a job: they tell everyone on the production team exactly what they need to do, and where. Your locations need to be actual places; everything else is what we see in the scene, so save it for the action section of your script.

Every scene gets a heading

Writing a slugline or heading for every scene can start to feel very repetitive. You still have to do it, though. Fortunately, if you're

cutting back to a scene you've already described, you can write "[Names of characters present] are as we left them" or "are [still doing what they were doing before]. For example, if your characters Buster, Lucille and Gob are playing poker in a scene, and we briefly cut away, and we return to find them still playing, you can write "Buster, Lucille and Gob are as we left them" or "are still playing poker." However, if anything has changed (characters have exited or moved around, props have been added or removed, anyone new has entered), don't use this. It's not meant to be a labor-saving device for writers who are tired of sluglines; use it only when brevity and minimal detail are the clearest way to describe what we're seeing.

SCENE DESCRIPTION/ACTION

Every slugline is followed by action or scene description (these terms are used interchangeably). Never go straight from slugline to dialog, even if we've seen the location recently. Like all script format elements, there are some rules and conventions for writing action that help everyone make sense of what they're reading.

Listing characters

Remember, your script is everyone's blueprint, so every time a slugline indicates a location and time, you have to also describe exactly what we see, especially the people. List *every* named character we see, and anyone who plays any part in the action, including extras: Waitress, Raiders Fans, Police Officer #3. *Even if they never speak*, if it's a part that would be cast, indicate that we see them. Even "bit-part" actors need to be able to flip through the script and find their character every time they're in a scene. The first time we see a character in the script, put their name in ALL CAPS. Usually, you'll only do this once – the first time we see the character in the script – but in short scripts, sometimes each scene lists all characters present in all caps at the moment they are first seen. The "Josiah and the Teeth" script uses this method.

Don't be afraid to let your characters come and go. If your scene description includes Mary, Lou and Rhoda, and sometime during their conversation you want Ted to walk in, just write "Ted

enters" in the scene description. Or you can get more descriptive: if Rhoda is mad at Ted, you could write "Rhoda storms out" or "Rhoda leaves in a huff." Just make sure that you indicate the entrance or exit *when it happens*; don't list characters who aren't there yet.

While we're thinking about characters, please always call your characters one thing and one thing only. For example, don't change "Sexy Waitress" to "Cute Diner Waitress" or "Barbara." If your character has a name, indicate it the first time we see the character in the script, even if the audience wouldn't know. For example: "An elderly wizard (DOUG) casts a fireball spell at a ballerina (GERTRUDE) practicing nearby." Then, for the rest of the script, use "Doug" and "Gertrude" (not "the wizard" or "the ballerina").

Indicating sounds

If a character makes a sound other than speech (sneezing, coughing, laughing, groaning, sighing, humming), put that in the scene description. Please note that *speech is different from sound*. You cannot write spoken words, or summaries or descriptions of dialog, in your scene descriptions. For example, don't write "Cersei scolds Joffrey for being a brat and sends him to bed without dessert" in your scene description. Any words that we hear, spoken by any character, will need to go in dialog. We can, however, hear Cersei growling, and we can hear Joffrey whimpering.

Not every writer gets to participate in post-production, so they might have no say about sounds or music. But there are times when a sound is crucial to a scene, so by all means put it in the scene description. Many writers capitalize important sounds if they are not typical of the location or scene, or need to be emphasized in order to understand what's happening. For instance, if your main character's apartment is located next to a construction site, then construction sounds are going to be normal ambient sound for that location. However, if your scene involves a character unable to hear the phone ring because of the noise, that is necessary to the logic of the scene and something "special" the sound or post-production team needs to notice, so you would capitalize CONSTRUCTION NOISE or maybe JACKHAMMER if there is reason to be specific.

Some writers also capitalize specific actions or objects that are important to the story. This can function as a way to remind the

production team that this moment or object is essential to the logic and clarity of the scene and it's not something that a director can omit or replace. An example:

INT. KITCHEN – DAY
LARRY DAVID is trying to use SCISSORS to open an
 unopenable plastic package. He STABS the package and
 SCREAMS in rage.

This type of capitalization helps the reader's eye land immediately on anything that wouldn't ordinarily be part of the scene, or things that are so important to the scene that they should be emphasized. They can also help activate the reader's visual/aural imagination and might inspire the cast and crew to have some creative ideas for a great scene.

Camera directions and special shots

Generally, the scriptwriter doesn't handle camera directions (tilting, panning, zooming in – anything that would involve actually touching the camera). Everyone on the production team has a job to do, and it's important to respect each member's expertise. You are the writer; the director of photography is the director of photography. Would you want the DP hovering over you and telling you what the characters should say next? Then you shouldn't tell the director where to put the camera. Your job is to set the scene – he or she will figure out when to pan.

It is best to write camera directions only when *absolutely necessary*, e.g. to indicate certain perspectives within a scene. For instance, if your scene is set in a sports bar that has a TV on the wall, and you want to let the audience see what's on the TV, you can use an "ANGLE ON." It looks like this:

INT. SPORTS BAR – NIGHT

A rowdy crowd of Giants fans drink and cheer as they follow the game on the bar's TV. Suddenly, the bartender gestures for quiet and raises the TV volume. Everyone stares at the TV.

ANGLE ON: TV

A young female reporter stands on Ocean Beach, in front of an oncoming tidal wave.

ANGLE ON: BARTENDER

The bartender reaches for a framed picture above the cash register; it's the same young female reporter. He starts to cry.

Another type of scene you might occasionally indulge in is the POV, or point-of-view shot. For instance, you might have a scene witnessed by someone looking through binoculars. Or you might switch to the perspective of a small child whose eyeline is at knee-level to the adults. You can indicate these shots as:

POV: SMALL CHILD

The small child wanders through the crowd of knees, occasionally peeking up a skirt.

If this point-of-view is necessary to the story – perhaps the small child glimpses a gun strapped to a leg under one of those skirts, and the audience needs to see the gun (not just hear the child say that he or she saw a gun) – then use it.

Writers are allowed to do this kind of thing only when it would be clunky and confusing to explain all of that action in prose, or because a certain visual really is non-negotiable to the story. Don't go overboard, though, and write your whole script divided into camera shots: you'll only annoy everyone on the production team.

The Office (first the UK version and then the US version) popularized a type of shot that you'll often see in shows: the "talking head" or "interview" scene. Your production team needs you to establish these in the script, or else they won't know that's what you want. Simply use a scene heading that says "[CHARACTER] TALKING HEAD." You don't need to give a location or include a scene description with talking head shots. Another shot that *The Office* and other shows use a lot is the reaction shot. While these are crucial to these shows' style and feel, you will probably not need to indicate them in your script. It's usually enough just to write how a character reacts in the scene description; the director will decide whether to do a closeup, and the editor will decide exactly how to insert it. But if your show relies heavily on reaction shots, you can indicate them with a REACTION SHOT scene heading.

Another common element in a script is the montage, which is a series of quick cuts that "collapse time," which means that they show a long process – maybe one that takes hours, days, years – through a few images that represent moments along the way. (The film *Team America* happens to contain a musical explanation of what a montage is and why you need one.) Simply indicate these with a MONTAGE scene heading. If a character or narrator is speaking over the montage, write the dialog with a voiceover (V.O.) parenthetical as discussed in this chapter under "Dialog."

Transitions

In many scripts, you'll see indications of how the writer wants one scene to transition to the next. These are not always necessary, especially when the transition is a simple cut – that's the default transition, so many scriptwriters don't bother with using it after every scene.

Writers are not always involved in post-production, and don't necessarily get to decide when to use transitions other than cuts. However, some transitions do have a major effect on the story, so it's fine to indicate them (and your script-formatting software will have an element you can choose, usually called "transition").

The most common transitions are: CUT TO, DISSOLVE TO, SMASH CUT, FADE IN and FADE OUT. Here are some basic rules for using them:

- CUT TO: Use only when it's completely necessary and essential to your plot and story to cut from one scene to the next at that particular moment.
- DISSOLVE TO: Used to show the passage of time (memories or flash-forwards). Also used to create a sentimental, nostalgic or sad effect.
- SMASH CUT: An aggressive, fast cut, used often to show a change in emotion, or something blowing up or for comedic effect. It's not recommended to use this transition often, as, again, it's one of those things a that will be worked out during shooting and editing.
- FADE OUT: The end of a script or a scene.

Externalizing thoughts and feelings

Note that viewers can't see thoughts or feelings; they can only see how those manifest in action and dialog – in other words, how they get externalized on-screen. Most importantly for writers who tend toward longer descriptions, *don't write anything that we wouldn't see or hear* if we were watching the scene. In other words, no mind-reading. For instance, if you've set up the story so that Marsha doubts that Jim is telling the truth, do not write: *Marsha doubts that Jim is telling the truth*. We don't know what Marsha is thinking unless she does or says something to reveal it. In fact, your tools as a writer are very similar to the tools an actor can use: you can only show the subtext and emotion of a scene through dialog and the characters' expressions, gestures, actions and dialog. Marsha can look doubtful, or storm out, or chuck a shoe at his head – all these things will show us her emotional state. A "mind-reading" line in the script will not.

Notes and comments

For the most part, you will not be writing notes to your production team, notes to self or any kind of commentary in your script. Your job is to convey your scenes through the slugline, the action and the dialog. However, occasionally, you might use a note to indicate something that would read awkwardly and take up a disproportionate amount of space on the page. There is a good example of this in "Josiah and the Teeth" regarding the sequence in which Lucy gives the camera crew a tour of the studio. The note was formatted automatically by choosing the "Note" element. If your software doesn't have this element option, you can place them by hand as separate line of scene. Except in very early drafts that you and perhaps a skeleton crew of co-writers will read, *never* write a note *instead* of writing action, dialog or anything that it's your job to know and write. Notes are not there to help the writer put off making decisions!

DIALOG

The dialog column is indented on both sides of the page. It is basically centered, with a few tweaks. The character name is close to center. (This will vary slightly in different script formatting software;

Final Draft places the character name 3.5 inches from the left page margin and 7.25 inches from the right.) The dialog itself starts on the line below the character name, and is wider on the page than the character name. This column is also nearly centered (in Final Draft, 2.5 inches from the left page margin and 5 inches from the right). Within this column, the dialog is justified on the left margin; this means that the letters line up in a perfect vertical line, just like the left margin of a book or academic paper. The dialog's right margin is not justified; it will be "jagged." Your page should *not* look like centered poetry verses that spread to unequal lengths on both ends, like this:

<div align="center">

JIM:

Marsha, I'm telling you I love you! You're the only one I've ever been able to talk to. I'd die if you ever left me.

</div>

The name of the character speaking is capitalized. As indicated earlier, always call your character one thing and one thing only. If you have an actor playing a character called Ski Bunny #1, then that actor is going to scan every scene for dialog labeled Ski Bunny #1. If the writer starts calling that character Cute Ski Bunny or Ski Bunny Girl, then the actor is going to ignore those lines because they appear to belong to a different character. Note, however, that if a character is speaking *about* Cute Ski Bunny, or *to* her, they can call her whatever you want them to call her *within the dialog*. It doesn't matter, because the Cute Ski Bunny actress isn't looking at the dialog itself to find her lines; she's only looking for her character's name capitalized and centered to indicate that she has dialog.

Usually, following the character name, you'll drop down a line and begin the dialog itself. Occasionally, though, you might add a *parenthetical*. The parenthetical is a direction or a bit of action that appears directly under the character name and above the dialog. It is nearly centered (in Final Draft, 3 inches from the left page margin, 5.5 inches from the right).

Parentheticals

These are used when it is absolutely necessary to direct the actor to (a) deliver the line in a specific way that would not be obvious

otherwise, (b) perform a gesture or action while speaking the line or (c) address different characters within the dialog block. Example:

BOB:

(under his breath)

It's been a long time since I heard a bird sing like that. Sounds just like my Daisy did, before she was eaten by that bear.

BRUCE:

(whispering)

Did you hear something growling? Over there, behind those trees. Sounded like a Sasquatch.

BOB:

(choking, laughing)

Dammit, Bill, now you've gone and made me spit up my Coors Light!

BILL:

(rises threateningly)

What? You drank my Coors Light?

(calling toward trees)

I know you're out there, Sasquatch! Stay out of my beer!

Commonly overused parentheticals include: angry, sarcastic, nervous, excited, bored, frightened – these would probably be clear from the context of the scene and/or the dialog itself. Try not to micromanage the actor.

Voiceover versus off screen

Two useful and important parentheticals are "Voiceover" (V.O.) and "Off-Screen" (O.S.). These do not mean the same thing! V.O. is

when a character or narrator's voice is heard, though the speaker is not part of the scene (as in *Arrested Development, Sex in the City, Jane the Virgin*). O.S. is when a character's voice is heard, but we can't see him/her because he/she is in a nearby room, or we're hearing the voice coming through a phone, PA system, etc. If you're writing a scene in which we see Dwight talking on the phone, and we can hear that he's talking to Angela but we don't see her, then Angela is O.S. You should also give Dwight a parenthetical reading, such as "(into phone)."

Running out of space on the page

If a dialog block is long, and a hard page break would leave a huge amount of space at the bottom of a page, write as much dialog as you can fit on the first page, and when you run out of room, put "(MORE)" beneath the dialog block. This is an important signal to the actor that their lines continue on the next page. Then, on the next page, when the dialog continues, put the speaker's name again with "(CONTINUED)" next to it. Most formatting apps will do this automatically.

7

Ask the pros

Hopefully, you have found much in this book that will help you move your ideas from your mind onto the page, hone your writing craft and cultivate your creativity. But the best advice of all, as always, comes from the people who are doing the work. The following interviews offer insiders' perspectives on developing, writing, performing in, publicizing and distributing web series, as well as some personal anecdotes that you might find inspiring. The interviews were conducted by Marie Drennan and Yuri Baranovsky from September through November 2017.

INTERVIEW #1: JULIA MATTISON

Julia co-created *Brooklyn Sound*, which won numerous major awards in 2016 including the Streamy Award for Best Indie, NYTVF awards for Best Actress in a Comedy and Best Editing, as well as a Comedy Central development deal through NYTVF. *Brooklyn Sound* has also been nominated for a 2017 Webby Award for Best Comedy Series. You might also know Julia from her viral music video "The INS-TAGRAM Song (Put a Filter On Me)"; her sketches on CollegeHumor's *Jake and Amir*; the 2016 web series *Turning the Tables*; and her numerous live comedy, cabaret and musical performances – there's really too much to list here, so do take a few minutes to read her full bio online!

Marie Drennan: How did you get the idea for *Brooklyn Sound*, and how did the series come about?

Julia Mattison: Noel [Carey] and I have been collaborators since we went to Emerson College together, and we knew we wanted to create a project that would allow us to play music in multiple genres, as we love writing music together and have always been drawn to more than one style. We thought about starting a band, but that felt limiting creatively. We ultimately decided to make a series about different bands making it in New York, because we knew it would allow us to play characters and jump into different genres. There were a few reasons we ultimately decided to set it at a recording studio. I was inspired by watching Dave Grohl's *Sound City* documentary, and my boyfriend at the time, who runs Virtue and Vice Studios in Brooklyn (where we filmed the series), always had amazing stories about the different kinds of characters he would meet on a day-to-day basis while working at the studio. It felt like the perfect location to meet the largest variety of characters, all concentrated in one space. Recording studios have this amazing revolving door where there are clients in every genre and with every kind of personality. We felt like the whole idea clicked when we decided to root it in the studio, because that would allow us to play crazy characters and create different kinds of music, without having to justify the existence of each character.

MD: How did you get into scriptwriting?

JM: Honestly, I feel like I fell into screenwriting by being an actor first. Every quality play or television show I would watch, or any script I would read, would be something I absorbed fully, and I think by being a fan of good material, I was able to mimic my way into the skill. With acting, writing, singing and comedy, I genuinely feel like I mimicked my way into being able to do it on my own. For example, as a kid I knew I wanted to be singer, but I didn't have any ability. I remember watching Whitney Houston sing, and I noticed that her jaw would shake when she hit really high notes, so for about a year I remember actively shaking my jaw while singing, because that might be the trick. It always started as a fascination with the people who were brilliant at the job, and then practicing and practicing until I kind of accidentally created my own voice and style. There's this great Conan O'Brien quote that I love, where he said, "It is our failure to become our perceived ideal that ultimately defines us and makes us unique." I love thinking about that when it comes to screenwriting, because I find myself writing shows that I would love to watch and trying to work towards reaching that

ideal that I've obsessed over in my mind. I still feel like I'm constantly improving as a screenwriter, but it's thrilling, because I feel like I get to watch my skill level, over time, slowly rise to my level of excitement about the material.

MD: How is writing for shorter formats easier/harder/otherwise different from TV-length or longer formats?

JM: I found it hard at first, because I like to indulge in some dialog. I'm bad at Twitter – I'm not the most natural at consolidating things down to the bare minimum. So I had to be reined in as I wrote the scripts, because I got excited about the world and wanted to explore it further, but I was faced with limitations financially and in regards to the time we had, which was actually the biggest blessing. I think writing for short form forces you to trim all of the fat, which is a wonderful thing. It feels much more powerful to make a statement in one sentence, than in three. I think I'll always feel like there can be more time to explore the world of the show, but writing for short form feels like a helpful tool, and I think it's easier, in that it's easier to see the other end of the tunnel. It's such a great venue for upcoming artists and creators who don't have all of the money in the world, or backing from a studio. It's a really satisfying way to give a sample of what you're capable of, or what you're imagining creatively.

MD: Do you think web series have changed the career path for aspiring creators?

JM: Absolutely. I think web series have allowed creators to hold much more power in the work they do, and in how they are seen. I think that power creatively is leading to bolder and more interesting material, which, based on views and interest, will change the landscape of what we're watching, and more accurately reflect the culture we're in.

MD: Have web series forced TV to evolve, and/or have they changed in order to be more like TV?

JM: Yes. I think networks have had to pay attention to the explosion of creative voices and independent talent, and they've realized that they have to welcome a whole range of new material in order to keep up. I think there is always some element of interest in having a series get picked up, and that can dictate the project, but I think

you can tell the difference between a project that is being made just to get picked up by a network, verses a project that is being made because it's a creative passion project, which will stand out because it has an original voice attached. It's always good to know the television landscape, and try to state your goal, but I think the priority is to lean into the originality of the material.

MD: Do web series afford creators more freedom than TV used to?

JM: Most definitely. Anyone can make a series now, and it's allowed creators to play and explore in a whole new way.

MD: How have web festivals been (or not been) helpful for creators? What's the festival world like?

JM: The festival world is wonderful and has been an unbelievable resource for us. My favorite festival, in regards to series creation and in opportunities, is the New York Television Festival. Through that festival over the years, I have been started development deals with MTV, Comedy Central and Audible and have met with countless network executives, agents and creatives, who I've continued to stay in touch with through the years. The doors that were opened by submitting to that festival led to incredible opportunities, and I don't think I would have been able to find all of that had my friends and I not submitted. Whether it's just to meet some fellow collaborators, or to try and sell a series, I can't say enough about the benefit of submitting to festivals.

MD: Are most web series creators hoping to get picked up by a cable/digital network?

JM: I think web series creators are hoping to get paid to make what they love to make, and being on a network makes that a viable possibility and a successful lifestyle. Getting picked up by a cable/digital network is a dream goal, in that the dream would be to create what you want to create with your friends, and call it a career. It does add a legitimacy, and fan base, to a project that might not otherwise find it, and it's an amazing thing to take your work to the next level. That said, I also think web series creators find freedom in making a show outside of the network rules and regulations. For example, an actor on a dramatic crime series on CBS might be dying to work on something funny and insane, and making a web

series allows them to explore another side of themselves creatively, without having to wait for permission. I'm not sure why that was the example, I don't know anyone on a dramatic crime series on CBS, but I can only imagine they're aching to get silly.

MD: What projects do you have coming up?

JM: Noel and I have another round of our musical comedy sketch show, *Noel & Julia's Wayward Brainchildren* coming up at Joe's Pub in New York City, which is a show where we get to explore all kinds of random comedy songs and sketches that we've come up with over the years. I'm working on a new short film called *Stomach People* that we're shooting in the spring, which is based on the actual imaginary friends I had as a child and explores what would happen if they came back and joined me now. I've been calling it "*Louis* meets *Inside Out*," but check back with me after I make it, because I still haven't finished it. We're gearing up to make a bunch of new music videos and sketches, which we hope to continue releasing over this next year!

INTERVIEW #2: ANGELA GULNER

After recovering from a decade-long battle with anorexia and bulimia, Angela teamed up with Yuri Baranovsky and Happy Little Guillotine Studios to create, write and produce *Binge*, a comedy series about her journey. Angela is a classically trained actor with an MFA in Acting from the ART Institute at Harvard; she has been seen on stages all over the world, as well as on-screen in *Stalker*, *Silicon Valley* and *Glee*. She is also a writer, producer and co-host of *Welcome to the Clambake*, a feminist comedy podcast.

Marie Drennan: How did you get the idea for *Binge*, and how did the series come about?

Angela Gulner: I was getting out of treatment and getting frustrated by the lack of agency that actors feel. And I kept hearing, with the internet anyone can create a TV show! You just need a good idea. And I thought . . . I have a good idea. Enter . . . Yuri.
Yuri Baranovsky: I had known Angela for a while and thought she was a fantastic actress. Then she came to me with this story – her 10-year battle with bulimia and then going into a partial

hospitalization program for treatment. She told me some stories from the clinic and they were both legitimately heart-breaking and hilarious. So, we said, "Let's write this."

AG: So, wrote it, we pitched it around through our reps; people liked it but they were scared of it. And so we decided that the best way to show them that this story was good was to make it ourselves.

YB: We shot the pilot over the span of 5 days, using my production company, Happy Little Guillotine Studios, and released it in late November and it blew up.

AG: We got coverage in all sorts of outlets, like Indiewire, Daily-Mail, Bustle and many more. We got over half a million views on YouTube, and the community feedback has just been ridiculous.

YB: My company has been making digital series for over 10 years, and in many ways, *Binge* was the most successful. We didn't get as many views as some of the other projects, but the interaction has been really intense –

AG: In a good way –

YB: In a good way, yeah. We get daily emails and comments; people have gone to treatment thanks to the show – it's been really amazing.

MD: How did you get into scriptwriting?

YB: I was an actor in college and fell into sketch writing with a friend of mine (Dashiell Reinhardt – who is one of the founders of HLG Studios). We put up the sketches in my school, and it went surprisingly well. I found that I really enjoyed the writing process and, on a whim, wrote a little one-act play called *11 Variations on Friar John's Failure* – a satire of *Romeo and Juliet*. The play got published when I was 19, and I really fell in love with writing. After a few more plays, another friend of mine, Justin Morrison (one of the other co-founders of our company) suggested we make a film off of it. Suddenly I had become a writer.

AG: I just got angry enough that I decided I had to do it. It's the only way I've gotten any traction as a creative person. The writing process isn't always a delight but having finished something feels really good. And it makes you care more about your experience as an actor when you're in a project from the ground up.

MD: How is writing for shorter formats easier/harder/otherwise different from TV-length or longer formats?

AG: You know what, I fell into digital at a time where length had really expanded. *Binge* is over 22 minutes and people really responded to it. But I feel like, as far as writing, it's very similar.

YB: Yeah, you know, it's of course easier to write something that's 5–10 minutes, because you can eliminate a lot of subplots, the story is condensed, it can be a lot smaller and there's way less to figure out. On the other hand, some stories really need the space, so then it becomes really difficult, it's like – how do I fit all this into 12 pages? So, it really varies depending on the story, you know? Luckily, it's getting to a place where the story informs the length, not the other way around.

MD: Do you think web series have changed the career path for aspiring creators/writers/actors?

AG: Yeah, in theory, yeah! The industry is still figuring out what to do with digital –

YB: Which they've been doing for the last 10 years.

AG: But the thing is, you can be a creator at any time; there is no barrier to entry. It's nice to be able to create your own work and not wait on other people for opportunities.

YB: Web series have been responsible for the success of my entire career. If it wasn't for digital, I wouldn't be a filmmaker. Yeah, it's hard, and it changes monthly, but if you're talented and smart and willing to work for your vision, you can really shine. Before, there was essentially one way to break into the film industry – now, it's sort of limitless. And that's overwhelming, on one hand, but also wildly empowering.

MD: Do you think web series have forced TV to evolve and change?

YB: I think thanks to digital, TV networks started realizing that telling good stories was actually important.

AG: Yeah, with so many outlets, we can have stories that can appeal to very specific demographics, it's not like, "This has to appease all of middle America for the next 40 years!" It's become much more specific.

YB: It's really created a golden age for TV entertainment. There are countless shows that are just amazing right now, and I think it's thanks to digital, first the original innovators of it, then places like Netflix and Amazon that pushed it forward.

MD: Do you think web series have changed in order to fit TV (get picked up)?

AG: Yeah, definitely. I think when shows like *Broad City* and *Insecure (Diary of an Awkward Black Girl)* get picked up for TV, it sort of informs the rest of us and pushes us to create content that can match up.

YB: When I started, it was almost a badge of honor to have content that looked bad. It was like, we're digital, we're raw and different and our footage is grainy! Now, it's like, oh, TV is watching and people are paying real money for real, high-quality storytelling. And it's made everyone really raise their game.

MD: Can web series afford creators more freedom than TV used to?

AG: Yeah, it really allows hashtag diversity to happen. White males have always been more likely to have their shows picked up, but now any kid, anywhere can make a show with his iPhone and tell a story that can grab an audience and turn him into an influencer. And suddenly that kid has a ton of power to create his own stories, and that kid can be any race, gender or color he wants.

YB: Yeah, before there were gatekeepers, and you had to play by their rules. Now, it's like – who can innovate fastest? Who can gather an audience? Who can be more real? Honest? Who can tell a good story? A show like *Binge* wouldn't be touched back then, but now, it's a proven commodity: we got to show studios that people want this story, and it's opened a ton of doors for us.

MD: How have web festivals been (or not been) helpful for creators? What's the festival world like?

YB: On one hand, I think it really helps create a community for digital filmmakers. You can find great talent at those festivals and it's always helpful to have your stuff seen. On the other hand, it sometimes feels a little bit like we're playing at fame, you know? There are very few festivals that manage to grab real executives who can make a real difference in the life of a digital series. So then, the point sort of gets lost – it's just a bunch of like-minded people, watching and discussing each other's work, which is great and can be very helpful, but it also doesn't necessary propel you upward. But there

are a few festivals that do and as the space keeps evolving and getting stronger, digital festivals will also become more relevant.
AG: I agree with everything Yuri just said.
YB: Stop it.

MD: Are most web series creators hoping to get picked up by a cable/digital network?

AG: It's hard to speak for anyone else, but I think that's definitely the goal for some of us. I mean, everyone wants to be on HBO, right?
YB: Yeah, I think, you know, if you manage to make your channel popular and you become an influencer and can self-fund your own content, then yeah, who needs anything else? But then again, a lot of these creators are still gunning for TV because, really, that's the height of it, right? We all want to be film and TV stars.

MD: What projects do you have coming up?

AG: I'm writing two features with my other writing partner *#Superslut* and *F#@kTruck* –
YB: Angela's titles are all G-rated.
AG: Yuri and I are also pitching two more series!
YB: Yep! We also have a series called *Dan Is Dead* that was made with Maker Studios that's completed and waiting to be released soon. And we're pitching multiple projects around with HLG Studios.
AG: I think to survive in this town, you've got to constantly be selling multiple things –
YB: Yeah, the more pans in the fire you've got, the more likely you'll . . . make pie? I don't know how the saying goes.
AG: I think that's it.

INTERVIEW #3: MATT LABATE AND JESSE WARREN

Matt Labate is VP of Channels, Strategy and Audience at Fine Brothers Entertainment (FBE). He is focused on stewarding FBE as it expands into a media company and network, driving content and platform strategy, and revenue and audience growth across all digital channels. Prior to that, Matt was VP of Creative and Revision3/Discovery Digital Networks at Reach, a social video agency for brands.

Jesse Warren is an award-winning Writer/Director/Producer, and co-Creator of the first million-dollar web series, *The Bannen Way*. This original Sony series garnered several Streamy Awards and generated over 14 million views on *Crackle.com* before being distributed on DVD, VOD and domestic/international TV. The 'Web Series/Feature' monetization model, innovated by *The Bannen Way*, has since become an industry standard.

Yuri Baranovsky: What would you say are the differences between short-format digital series and traditional TV-length shows in terms of writing, pitching, getting picked up, etc.?

Matt Labate: The obvious difference is that, for the most part, there's still a budget difference between traditional and short format. Buyers in 2017 still aren't paying as much for short-format digital series, as a general rule, than they are in traditional television, nor is it easy to support the cost of digital series on just AdSense or Facebook monetization. This means the creative process from soup to nuts is more cramped due to available resources.

But on the flip side, as a creator you can find more creative freedom in digital web series, and potentially bypass the still gatekeeper-heavy television business. There's a lower bar for budgets on social platforms, and also a lower requirement for making sure you follow all the premium and costly production practices as television does, but conversely, there's a high bar for authenticity and platform intentionality online.

Both television and digital have the same need: how to you drive viewers to your show, and keep them there? There's an old adage in business that you are only as good as your last film/project/success/performance, which definitely still applies to getting your show sold; you need to enter the room with prior success, either with another hit show, and strategic partnership, or an established audience on digital platforms. This is why we see influencers getting cast in television, although there's still a skills gap with some of these young digital stars as they tend to have less training as traditional actors. (Although they don't always need that training, and may never need it, since once you aggregate massive audiences to your brand on social platforms, you can leverage that smartly for success.)

A very important piece is how technology and creative are much more entangled on the digital side than television. You have to make creative choices that are based on platform features and audi-

ence expectations, for example to shoot in vertical for Stories [on Instagram] or 16:9 for more traditional online video players. You also have to be an expert in how video is distributed online, so that you can develop your creative to integrate things like audience calls to action to share and engage when it's relevant.

Jesse Warren: TV has a longer tradition and has become more set in its ways. Writing for TV is much more of a haiku because it is structured around advertising, and there are very specific episode lengths and formulas for how a pilot turns into a series, whereas digital is still the "Wild West" and studios are still experimenting with models.

Same goes with pitching: it's much more competitive in TV, partly because there's more money at stake. In digital, you have so many companies with no prior experience developing narrative content that all of a sudden want to have their own digital network; it's a different beast trying to pitch an executive who doesn't know *anything* about character or plot development.

TV has become so insanely competitive, it's hard enough to get a pitch sold, it's harder to get a pilot order, it's rare that your produced pilot even gets picked up to series, and near impossible to keep it on air past one season. TV has changed its strategy a bit in recent years, where they seem to be investing more in developing series to see which ones show potential: ordering more pilot scripts and even shooting multiple episodes as a "test" before ever deciding whether to air it.

In digital, there are these polar opposites, where anyone with a camera can shoot, edit and distribute a series in hopes it goes viral . . . or it seems that, if a studio invests in a large enough digital project ($100k+), they're likely motivated to see it through distribution of at least the entire first season. Mostly because these executives' own budgets are limited and they're still trying to prove to their superiors that digital content is a viable business opportunity.

YB: Do you think there are differences between Netflix/Hulu/Amazon originals and old-school web series? What would you say are the chief differences?

ML: On one side, digital originals teams have access to more resources since it's a loss-leader for the new digital studios' strategy to kill the traditional Hollywood studios. On the other side, social giants have amassed large audiences and also want in on the game,

and offer creators other value than just production resources. We are currently experiencing the most seismic disruption the media industry has ever seen, and the major players of tomorrow are experimenting with lots of different models and finding out what works. But, it's important to note that the lines are blurring, and all serialized content regardless of distribution still need to be compelling, not tone deaf to the audience, and entertain or move them to be successful.

All three of the new digital studios – Netflix, Hulu and Amazon – have leveraged their "first-mover" success in delivering content online combined with successful business models to access resources that can support premium production. Netflix has taken the HBO model of building a content delivery system using premium Hollywood films and television and aggregating a large audience. Along the way they disrupted the media distribution system and created a better user experience than cable and television, winning over consumers in a massive way. Amazon built a massive online shopping mall for everything in the world, and has obvious aims to win everything at all costs. Hulu was the anomaly, a joint venture between highly competitive legacy media companies to offer a streaming solution for consumers of content that was traditionally distributed via television. Each of them have massive revenue streams to draw upon to create content, and continuing the HBO model of building a prestige originals strategy on top of a licensing and distribution business in order to differentiate themselves and charge premium fees to media consumers.

Now is a great time to be a creator if you can get access to them as these new studios ramp up their spending and green lights. In 2017 Netflix is spending $6 billion on original content, HBO is spending $2 billion, and Apple is dipping in at $1 billion. (By comparison, ESPN spends $7 billion and NBC around $4 billion.) This won't last forever, as it's a loss-leader land-grab at the moment as the legacy media companies wind down. You can see this with the recent push of Netflix into lower-cost content like stand-up comedy specials, and even starting to cancel series that are underperforming. The characteristics of what they are buying generally follow traditional television formats, although there's niche markets that don't exist elsewhere like documentaries that without Netflix, Apple and others would be struggling.

On the other side, Facebook and Google/YouTube have amassed massive audiences in a different way, and it's a great place for creators to try out ideas and get content out faster. In addition to being able to go direct to an audience, creators also have a wealth of

format and platform techniques as well as creative devices to take advantage of that audiences expect. It's more difficult for an independent web series to thrive, however; since it's a very crowded space where cat videos, personal photos, memes, viral social posts compete with publishers, celebrities, brands and major film franchises all on the same level.

JW: When *Bannen* came on the scene, the idea of a web series – or any original narrative content not on TV or in a movie theater – was considered (at best) an avenue for talent to rise to the top and find "legitimate" TV or film careers. The digital medium was dismissed in terms of its potential to make money. Now that various studios and even non-entertainment companies have taken risks to show that content *can* be monetized by clever packaging, and that more eyeballs can be brought to their brand, which leads to higher sales ... now we've got bigger money coming into the digital arena. So now we have all this *amazing* content right in our faces, it's very difficult to keep up with every show that has an 8.5 or higher rating on IMDb.

Nowadays, there's a real ability to locate your target audience as well, so we can see all types of content sprouting up for specific niche audiences at various budget levels.

YB: Do you think digital festivals are helping the genre? Any thoughts on them?

ML: Digital festivals can be helpful in getting the word out, and if you are an independent or smaller web series, you should take all the help you can get. They are a great place to find the super fans, to access smaller passionate audiences, but increasingly there are fewer players controlling larger and larger audiences, and it's more difficult to push anybody out of the channels they normally visit. They are just a piece of the discovery challenge, however; and the big platforms and big money have definitely etched a place for themselves in the crowded digital ecosystem and are using their muscle and money power to outcompete. Discovery of content is the biggest problem facing any creator, and there are lots of techniques that can be employed to optimize, from tailoring creative and developing for share and engagement, to casting talent with reach, to partnering with people that have large followings, to using paid media, to identifying passion audiences via blogs and festivals, to selling your show and looking into established digital marketing techniques.

JW: I haven't followed very many digital festivals. But I think competition in general motivates artists to seek recognition and thus try to create content that stands out from the herd. In that sense, it's a good thing.

YB: How have digital series changed since you started in this business?

ML: I've been working on the digital side since Google acquired YouTube, and in independent film before that. In many ways, telling a story in audio-visual form hasn't changed much, and the skills required to do so well are still the same. You still need good video/audio, writing, acting, direction and editing. And an instinct for how humans respond to story and emotion. But the nuances have evolved, and what I find exciting is that some techniques of storytelling have evolved, both creatively, and tactically. Creatively, you now have an audience that is less passive; they are more likely to share, remake and remix your content, and embracing this in the development stage can be incredibly powerful. Tactically, you now can take advantage of new technologies and techniques, including VR [virtual reality], branching narratives tech, disappearing videos, audience development, analytics and cross-platform storytelling.

JW: It's strange. It seemed after *Bannen* came out, more studios were motivated to invest real money in this space. In the range of $1 to $2 million dollars for a digital series, which could either be cut into a six-episode series or 90-minute feature for further monetization. The divide between what we consider a "web series" and "tv" was growing smaller. But after some big digital projects didn't yield the results studios were expecting (or hoping), the true budgets started dropping again on the whole. Studio execs all of a sudden didn't have the budgets they were promised earlier that year. As technology starts allowing people to create better looking content for cheaper, the studios start asking for creators to deliver more content for smaller budgets.

Once Netflix poured in tons of money and started churning out tons of quality content, it changed the whole game again. It created a new category of digital content that is TV-like, crossing over the great divide of digital content. This attracted top talent away from features and into serialized storytelling, of which we are now in the golden age. So, while the term "digital series" has a broad definition, it seems these extremes are once again being embraced, of either TV-quality digital projects or super low-budget web series.

It's not that $1- or $2-million dollar digital projects aren't getting made, they just don't seem to be getting the attention they once did. Maybe it's because companies have learned how to target those niche audiences that matter to their brand without having to spend tons of money casting a wide net on mainstream advertising.

YB: Where do you think it's going?

ML: In many ways things will stay the same, but the players and pipes will change. On the business side, legacy players have a massive problem with too much overhead, "shrinking pie" of audience and revenue and oftentimes an inability to understand the new ecosystem and move fast. The technology and social media "upstarts" have massive control over the online audience and the flow of ideas, but less understanding of the creative process. Not all will survive, and both sides will have to learn to integrate the other's strengths. As terrifying as this sounds, this is ultimately good for the creator, since at the end of the day, skill in building and entertaining audiences is still only possible by a relatively small number of people. It's the best time to be a creator; access to tools of distribution and global audiences has never been easier. This won't change, but the business is being more solidified, and gatekeepers are re-entering. The audience is more powerful than it's ever been, and that can be both a blessing and a curse. Creators and brands who don't engage or build trust with the audience will be left behind.

JW: Clearly we're going to see more serialized content for all types of companies to showcase their brand. For non-entertainment companies, it'll be less about creating compelling content than it will be about visually displaying characters that are relatable to you and represent their brand. It will be a platform for you to return to so they can sell you more of their products.

What I'm personally excited about is seeing where AR, alternate reality, will be integrated. And ultimately how we can use digital content combined with live entertainment or some other form of meaningful interactivity to create more immersive experiences.

YB: What are some pitfalls of digital?

ML: It moves fast, platforms, features, business models and audiences are constantly changing. As easily as you can blow up, you can be forgotten, or worse, actively taken down. The echo chambers and amplification of fake news affects both politics and content

popularity. Until the robots take over, this will always be a challenge to the creator.

JW: Finding a proper distribution channel that connects your product to the right audience. Just getting people to see your show.

Sometimes it's hard to create specific content for a company that doesn't know what they want, how much money they have or how they're planning to distribute the project.

YB: What are some advantages of digital?

ML: Creating content for digital can offer creative freedom and the possibility of rapidly growing a large global audience. There are more ways to tell a story and engage an audience. New formats have been established, from vlogs to disappearing videos. New technology is available, creators can broadcast live from their phones from anywhere, or invent a fantastic world to be experience in VR. You can engage an audience and bring them into your creative process through idea and video submissions. New buyers are popping up all the time as various entities aim to control audiences in order to access advertising and subscription revenues, and new deals are available to smart, talented and powerful creators.

JW: Not as many restrictions as traditional media, since there are more ways to monetize content than just fitting them around commercials.

More opportunity to create something innovative.

YB: What advice would you give for people entering the digital entertainment realm?

Start creating. Find others to collaborate with. Follow creators. The only way to build an audience, understand the landscape and learn the vernacular and culture is to immerse yourself into it.

JW: The trick is walking the line between giving your studio the content they need to enrich their brand . . . while embracing your original voice so you stand out as an artist. It's important to look around and see where the state of digital is right now. Then look two steps ahead and imagine where it could be in the future. Then come back to reality and take *one* step forward so you create something innovative but still relatable to the current state of the medium.

Appendix A
Sample script

BROOKLYN SOUND

"Ep. 1, Josiah and the Teeth"

Written by
Julia Mattison

COLD OPEN

INT. RECORDING STUDIO - LIVE ROOM - DAY

JOSIAH AND THE TEETH, a Mumford and Sons-type band of
beards is tuning instruments and working out harmonies.

We see a banjo, guitars, tambourines, a single drum, a
shoe filled with sand, someone twirling their perfectly
quaffed mustache, etc.

JOEL, head engineer, 30, is at the console.

 JOEL

 Alright, you guys ready for a take?

 JOSIAH

 Oh, we're ready, brother. Pieces?
 Scruples? Clift?

PIECES, SCRUPLES, and CLIFT nod profoundly.

> JOSIAH (CONT'D)
> Jebediah? Corn? Bedejiah?

JEBEDIAH, CORN, and BEDEJIAH do the same.

> JOSIAH (CONT'D)
> Alright . . . it begins.

JOSIAH starts humming softly on a note, eyes closed. Everyone else joins in quietly in harmony, slowly swarming together like a pack of animals. It doesn't sound bad. The group approves. Some pat each other on the back, one gentleman tips his corn cob pipe.

Josiah and Jebediah nod at each other. Through the control room window, they nod at JOEL, who hits record.

The band takes a breath.
TITLE CARD

> JOSIAH AND THE TEETH
> (singing)
> *AAAAAAAAAAAAAH! HEY!*

END OF COLD OPEN
ACT ONE

INT. RECORDING STUDIO - HALLWAY - DAY

Camera crew, somewhat hidden, captures LUCY, 24, on the phone with a potential client.

> LUCY
> Yes. We are offering two-for-
> one pizza parties. That's two
> twelve-hour studio sessions for
> the price of one, plus we buy you
> a pizza for dinner. Yes, I know,
> it does seem too good to be true.
> Yes, we can do pepperoni.

PAM, intern, approaches Lucy in the hallway.

 PAM
Lucy, the documentary crew's here.
They want to interview you.

 LUCY
 (still on the phone)
Pam, that's not today.

 PAM
They're waiting for you –

 LUCY
Well, I don't know, tell them to
go suck on my. . .
 (sees the camera is
 filming her)
Oh, excellent. Good . . . good day.

Lucy kind of nods her head as if to bow.

LUCY TALKING HEAD

 LUCY
I'm Lucy. I'm the owner of
Brooklyn Sound. I've been working
here for, technically eleven years
now, though I guess I've really
been here my whole life.

MONTAGE:

LUCY giving a tour, showing an old photograph of her
parents, a fake album cover for Shadowland, etc.

 LUCY
 (V.O.)
It's a family business. My parents
opened the studio in 1974 and
they were lucky to get a lot of
major success very quickly. They
recorded Lionel Gould's album
Shadowland, I think only six
months into opening the place.
After that, things just blew up.

INT. RECORDING STUDIO - HALLWAY - CONTINUOUS

Lucy shows a wall of some old photographs.

> LUCY
> I love this picture. There's my
> mom Wendy, my dad Ed, and there's
> Lionel Gould. It's kind of hard
> to tell it's him. . . . He didn't
> let anyone take pictures of his
> face because he was worried about
> the camera stealing his secrets
> through his eyes. Great guy.

It's just a picture of the back of a head.

Lucy shows a makeshift "altar" of her parents. An old
photograph of them with a burning candle.

> LUCY (CONT'D)
> My parents passed away about four
> years ago. It was, um. . . . They
> lived amazing lives. . . . As you
> can see.
> (she gestures to the
> studio around her)
> They left me the studio, which I
> knew was going to happen. I just
> didn't think I was going to be,
> you know, 24 when I started running
> the place. I'm not gonna lie to
> you, it's been really hard. The
> industry's changed a lot.
> Making rent is a monthly fiesta.

A wall light falls. Pam runs to it.

> LUCY (CONT'D)
> (gesturing to the fallen light)
> Our facilities are. . . . Yes.

Lucy moves with the camera to get out of Pam's earshot.

> LUCY (CONT'D)
> Honestly, we might lose the studio
> this year. . . .
> (horribly depressed beat)

> But, that's why you guys are
> here! Hopefully you can help us
> get the word out, and show people
> the great work we do.

MONTAGE:

B-roll of Pam smiling and victoriously holding her
wrench in the air, struggling to carry too many boxes,
eating tupperware out of the fridge marked "Joel."

> LUCY
> (V.O.)
> We have a great team here, a
> great family. It's me, Joel, and
> our intern Pam.

MONTAGE:

B-roll of Joel doing a bad job of acting natural as we
works on Pro Tools, moves a fader on the console an
eighth of an inch, sips coffee.

> LUCY
> (V.O.)
> Joel's our head engineer. He's
> an incredible talent. He's been
> working with me here for ten
> years now, so just about six
> of those were under my parents'
> wing. He's got a great ear and
> a lot of patience — two things
> that really help keep our clients
> happy.

INT. RECORDING STUDIO - CONTROL ROOM - DAY

Joel is at the console, dealing with Josiah and the
Teeth, who are in the live room.

> BEDEJIAH
> I can't hear the vibrations of my
> brothers' hearts. Can you turn
> it up?

 JOEL
 That's not something I can help
 you with.

 JOEL TALKING HEAD - CONTINUOUS

 JOEL
 I love this place, man. It's an
 engineer's dream. Some of the
 all time greatest albums were
 recorded here. *Talking Into
 Sinks*, *Osteoporosis, Everyday
 Dancers*. It blows my mind to
 think about the music that has
 traveled through these walls.

INT. RECORDING STUDIO - LIVE ROOM - CONTINUOUS

Josiah and the Teeth are singing a really off harmony.

 JOEL TALKING HEAD - CONTINUOUS

 JOEL
 Some days are better than others,
 but, uh. . . . I'm living in the
 lap of music history, man. There's
 no place better than this.

INT. RECORDING STUDIO - LIVE ROOM - DAY

Josiah and the Teeth are now mid song and doing well.
They're connecting, and everyone sounds great. We get
to hear an exciting minute of the song.

JOSIAH AND THE TEETH FULL BAND TALKING HEAD

JOSIAH, PIECES, SCRUPLES, CLIFT, BEDEJIAH, JEBEDIAH, and
CORN sit together for a group interview.

 JEBEDIAH
 Oh, we love recording here, it
 feels like a second home.

 JOSIAH
Yeah, Joel and Lucy are great.
They know just what to do with
our sound.

 PIECES
They make us feel good about our
work. Joel's got an amazing ear.

 BEDEJIAH
Yeah, yeah, it's true.

Beat.

 CORN
Plus we all live in a cave by the
train, so it's nice to be in a
bigger space for the day, too.

 DOCUMENTARY INTERVIEWER
 (O.S.)
I'm sorry, what was that?

 CORN
. . . What?

MONTAGE:

As Jebediah speaks, we see B Roll of the band working
in the studio, listening back on a song, etc.

 JEBEDIAH
 (V.O.)

It's a hard time to be in the
music industry right now. We're
not making money off of our
music, but we have to give out
our music to gain a fan base in
order to tour.

JOSIAH AND THE TEETH FULL BAND TALKING HEAD - CONTINUOUS

> JOSIAH
> We're doing what we love, but it
> comes at a price.

ANGLE ON:

SCRUPLES sneaks over to a trash can and grabs something
out of it. PAM slaps his hand. She sees he pulled out
a half eaten candy bar. They split it.

JOSIAH AND THE TEETH FULL BAND TALKING HEAD - CONTINUOUS

> CLIFT
> Oh, and we <u>love</u> Pam.

Whole band agrees.

> CORN
> She's great. A real music fan
> with a great heart.

> JOEL TALKING HEAD

> JOEL
> Oh for sure, Pam's been a great
> help. She's a. . . . A bit of a
> mystery. Very quiet. The bands
> seem to love her, but I don't
> really feel like I know her, you
> know? She's been here for a couple
> months though now and seems like
> she's gotten into a good groove
> with everyone.

PAM TALKING HEAD

> PAM

> I'm Pam. I've worked here for two
> and a half years.

INT. RECORDING STUDIO - CONTROL ROOM - DAY

JOEL is working at the console. LUCY pulls up a chair to join him.

 LUCY
 Hey, listen to this.

Lucy holds up her phone, and we hear a voicemail from their landlord, Jillian.

 JILLIAN
 (O.S., phone)

 Lucy, hi. It's Jillian — your
 landlord? Smooth hair, great ass?
 (She laughs)
 Anyway. Listen, I've got a few
 potential tenants coming by to
 check out your space later this
 week. Gotta make some moves before
 that old lease of yours expires.
 Really, how old is it? Put that
 thing in a museum!
 (she laughs)
 Anyway, if I don't see you. . . .
 Okay, that'd be great. Just let
 me know when you're done making
 that devil piss of yours and
 we'll come through. Alright, bye
 now. This is Jillian.

Beat.

 JOEL
 That's a joke.

 LUCY
 No, she's not joking. She doesn't
 like us at all. We've been late
 on most bills, she hates music—

 JOEL
 She doesn't hate music.

 LUCY
 She called it "devil piss."

 JOEL
 And they're brilliant.

Joel holds up an album that says "Devil Piss."

 JOEL (CONT'D)
 We're renewing the lease.
 Everything will be fine.

 LUCY
 I don't know. I'll figure it out.
 How are these guys doing?

 JOEL
 They're sounding good. They're
 only doing live takes so that they
 can "feel each others spirits."
 And I think they're eating out of
 the trash.

 LUCY
 Oh God. . . . Have they paid us?

 JOEL
 Just the deposit.

Lucy talks to the band in the live room from her place
at the console.

 LUCY
 Hey guys? I'm sorry to do this in
 the middle of your session, but I
 don't want an incident like last
 time. Have you guys settled how
 you're going to pay us for the
 rest of the day?

 JEBEDIAH

 Uh. . . .

 JOSIAH
 (harmonizing with Jebediah)
 Uh. . . .

ANGLE ON:

In the live room, the band members start to all join in the "uhh-ing" as they nervously look at each other. Some nod their heads yes, while they all start to grab their things (hobo bindles, bags of sticks, etc.). They begin to move with the guise of a traveling band, never breaking their stare with Lucy and Joel. When Lucy and Joel realize what they are about to do, they run.

Beat.

> LUCY
> Damn it!

Joel casually takes a sip of his coffee. This has happened before.

LUCY TALKING HEAD
LUCY takes a deep breath and smiles.

> LUCY (CONT'D)
> Never a dull moment here.

END OF EPISODE

TAG:

We see Josiah and The Teeth run down the street in SLOW-MOTION, carrying all their things (as well as food they've stolen from the studio, maybe Scruples stole the trash can, etc.) as LUCY chases them. The song they recorded, now fully mixed, plays.

_____Appendix B
Writing mechanics guide

As a media writer, you must constantly strive to express precisely what you mean, and never anything you don't mean. The errors discussed here are especially problematic because they can change the literal meaning of your sentences and cause confusion. They also weaken the context/tone/emotional core of your writing.

In dialog, it often makes sense to break rules. Most characters don't speak in perfect, formal sentences; we write what the character would say, then we "hear" the lines spoken. But regardless of the content of the sentence, we still have to correctly spell and punctuate what's there, so that the reader can easily navigate the sentence.

END PUNCTUATION

Every sentence needs end punctuation, even if it is an "ungrammatical" in other ways (especially common in dialog). Here are your options:

> **Statements** end in a period or exclamation point even if they indicate uncertainty. For example, "I wonder whether Jaime likes me." "I don't know where Westeros is." "I'm lost in Mereen." These are statements, not questions. Even one-word sentences need end punctuation. Examples: "Whatever." "Yeah." "Uh huh."
>
> **Questions** end in a question mark even if you imagine the line spoken as a statement. Occasionally, you might

change the punctuation to control the actor's inflection; for example, notice how "What's up?" conveys a different tone from "What's up." Generally, however, don't misuse punctuation to control the actor: you punctuate the lines according to what they are (question/statement); the actor and director decide how to deliver them.

Run-on sentences: Commas are not end punctuation. Example: "Are you crazy, what are you doing, that dragon breathes fire!" actually contains three sentences: "Are you crazy? What are you doing? That dragon breathes fire!"

Non-words/sounds in sentences: Even exclamations that are nonsense words or just sounds need end punctuation. For example, "D'oh!" "Hmph." "Mrh?" "Psst!" "Eew!" "Brrr." "Huh?" "Hmm. . . ."

Interruptions: If a person is cut off suddenly before finishing a sentence, end the sentence with a long dash (not a hyphen). Example: "That's a –" means that the person got interrupted before he could say "White Walker." The dash is sufficient end punctuation, but if the sentence is a question, you can add a question mark: "Is that a – ?"

Unfinished thoughts: If a person trails off without finishing a sentence, use " . . . " (ellipsis). Example: "I wonder whether. . . . " If the line would have been a question, it should also have a question mark: "What did I just. . . . ?" **Note:** Ellipses can indicate a pause in dialog, but too much of this drives actors crazy and should be avoided.

Extra end punctuation: Occasionally you might use "?!" or "!?" – but avoid "!!!" or "???"

COMMAS WITH DIRECT ADDRESS

When a speaker calls someone by name, nickname, title, etc., the *addressee* is separated from the rest of the sentence by commas. **Note:** The addressee might consist of more than one word.

The addressee can come first in the sentence

<u>Robert</u>, you're a terrible king.
<u>Maester Percell</u>, go back to med school.
<u>Margaery</u>, what's up with that dress?

<u>Ygritte</u>, don't shoot!
<u>Men of the Night's Watch</u>, close the gates!
<u>Cersei</u>, who does your hair?

The addressee can come in the middle of the sentence

Yes, <u>Stannis</u>, yours is the strongest claim.
No, <u>Tyrion</u>, you can't get drunk at the wedding.
I'm not stupid, <u>Arya</u>, I can tell you're a girl.
Beware, <u>people of Westeros</u>, winter is coming.
Hide, <u>goats</u>, here comes a dragon!

The addressee can come last in the sentence

Yes, <u>Khaleesi</u>.
You know nothing, <u>Jon Snow</u>.
Quit hogging all the lemon cakes, <u>Sansa</u>.
Got any onions, <u>Davos</u>?
Get your story straight, <u>Melisandre</u>.
Your life is a bummer, <u>Theon</u>.
Run, <u>little lord!</u>
Get real, <u>Renly</u>.

Terrible things can happen when the direct-address comma is left out. Compare these sentences:

It's all over, Littlefinger./It's all over Littlefinger.
I don't know, Lord Varys./I don't know Lord Varys.
Let's eat, Bronn./Let's eat Bronn.
You're the worst, Ramsay./You're the worst Ramsay.
We'll get through this, Catelyn./We'll get through this Catelyn.

Note: "Hi" and "hey" don't need commas, but "hello," "bye" and "goodbye" do.

Hi Jaime.
Hey Khal Drogo!
Hello, Lady Olenna.
Bye, Benjen.
Goodbye, Brienne of Tarth.

Another note: A name/nickname isn't always direct address, so *don't splatter commas* whenever you see a name:

Correct: I just met a man named Hodor.	*Incorrect:* I just met a man named, Hodor.
Correct: Ned isn't as sharp as he used to be.	*Incorrect:* Ned, isn't as sharp as he used to be.
Correct: My squire just called me stupid.	*Incorrect:* My squire just called me, stupid.

OTHER COMMAS

Conversational words plunked into sentences, such as "oh," "well" and "man," are "quarantined" with commas. Exceptions: "Oh no" and "oh well" are so common they don't take a comma.

> <u>Oh</u>, is that right? (But: Oh no!)
> <u>Well</u>, I disagree. (But: Oh well.)
> <u>Man</u>, that's messed up. No way, <u>man</u>.

CONTRACTIONS

An apostrophe *replaces* omitted letters/spaces/numbers: "cannot" becomes "can't"; "it is" becomes "it's"; "I have" becomes "I've." "1970s" becomes "'70s" (not "70's"!) because the apostrophe *replaces* the "19."

Apostrophes replace the "g" in "ing" verbs and nouns *if* you want the word pronounced that way: *goin', chillin', warg huntin', claimin' the Iron Throne, King's Landin', Purple Weddin'.*

POSSESSIVES

If the dragon has a toy, then it is the "<u>dragon's</u> toy." If two dragons have a toy, then it is the "<u>dragons</u>' toy." Odd plural possessives: "children's," "people's," "women's," "men's." WEIRD EXCEPTION: Possessive "its," as in "The dragon wants <u>its</u> toy," seems like it should have an apostrophe, but it can't, because "it's" is already used as a contraction.

SLANG

Slang words have standard spellings. Look them up if you aren't sure. Common examples: "Dammit," "ain't," "gonna," "gotcha," "gotta," "jeez," "yeah" *(never "ya" or "yea")*. If you aren't sure, look the word up.

ABBREVIATIONS

Use them only if you *want the actor to pronounce them that way*: "U.S.," "ASAP," "TV," "a.m.," "p.m.," "RSVP," "GPS," "LOL," "OMG," "IMHO," etc. But write the whole word(s) out if you want the actor to say them.

Don't use abbreviations that can't be pronounced: write "miles per hour," not "mph"; "street," not "St."; "October," not "Oct."; "pounds" (not "lbs"); "highway" (not "hwy"); "seriously" (not "srsly") etc.

Spell business names as they are officially. Search for the company's web page rather than using the URL. Examples: *YouTube, Facebook, Gmail, iPhone*. Use ".com" (not "dot-com") in dialog: "Bob has a match.com profile." (Dot-com is a word, as in t*he dot-com bubble*.) If you *don't* want the actor to say ".com," don't write it.

SYMBOLS

Never use symbols: &, @, $, %. Write what the actor will *say*: "five dollars," "fifty percent," "third marriage." Don't use superscripts ("1st," "100th"); spell "first," "hundredth," etc.

NUMBERS

It's easier for actors to read numbers spelled out: "eleven dollars," "five hundred thousand people," "three-point-five seconds," "one million years," "someone in his early twenties," "twenty-fifth percentile."

Some numerals do not get spelled out: years and centuries ("2016," "900 B.C.," "the late 1800s"); commonly written numbers

("911," "9/11," "Astronomy 101"); and proper names ("I-5," "Highway 280," "Fortune 500," "PlayStation 4").

OTHER CATASTROPHES

- "Your" vs. "you're"; "then" vs. "than"; "there" vs. "their" vs. "they're": And other homonyms.
- "Should <u>have</u>," "would <u>have</u>," "could <u>have</u>": Not "of."
- "OK" or "O.K.": not "ok" or "o.k." You can also write it out as "okay."
- "Every day" vs. "everyday": "I wear this outfit <u>every day</u>." "It's my <u>everyday</u> routine."
- "Myself," "yourself," "himself," "herself": Write as one word, not "my self" or "your self."

AND FINALLY. . . .

Sloppy mistakes can make your reader think that you're not paying attention to what you're writing. The director, actors, producer, etc. might lose confidence in the script (and in you). Here are some proofreading tips that really work – try them!

Proofread separately from writing

Don't expect to catch all of your errors while you're writing – generating and analyzing are very different brain functions, so don't try to do both at once. Give yourself time to set the script down for at least a few hours before you do a final proofread.

Proofread on paper

Lit-up screens tire the eyes, and some punctuation is too small to see.

Allow enough time for proofreading

Don't rush, or you'll miss errors. Plan to make one last pass.

Don't trust spell-check

It doesn't know the word you *want*, only the word you *typed*. If you're using a school or public computer, other people might have "taught" spell-check to accept incorrect spellings. Also, spell-check doesn't always check words in all-caps (sluglines, SFX). Do the final check yourself.

Use the dictionary

Online dictionaries are fine as long as they are standard English dictionaries, such as The Free Dictionary, Merriam-Webster, Oxford English, etc. Be careful with the online Urban Dictionary; the people contributing definitions don't always understand the word (or how to spell it).

Clever trick: read your script in a different font and/or color

The visual difference will help you see what's really on the page.

Another clever trick: go back to front

Try reading the script line by line from the back to the front; this keeps you focused on the words and punctuation on the page rather than the meaning of words/sentences.

Read

Read everything, not just websites, online articles and blogs, which tend to have errors, some caused by rushing to meet deadlines and others by writers who just aren't sure what's correct and what's not. Print sources are generally more trustworthy, especially books.

Get help

Nobody catches every error in their own writing; we've looked at it too many times to really see what's there. So get some more

eyeballs on your script: go to your professors' office hours, see if your school or department has a writing lab or other tutoring available, call in favors from your family and friends – anyone you can find who will look over your work. (And, of course, be willing to return the favor!)

Appendix C
A warning for instructors

One important skill your students need to be cultivating is *learning to let go*. Many professors whose writing classes collaborate with production classes have experienced the emotional firestorms that can erupt when the writers see what the production students have "done to" their script. There is *always* bound to be a big difference between what the writers imagine and what the produced episode actually looks like. The complaints are always the same, and sometimes unfair to the other people on the team:

- The actors seem miscast, especially if they resemble a celebrity – you can't have a Taylor Swift lookalike play an attractive character's nerdy, mousy roommate (and if your writers hate Taylor Swift, they will bristle even more at the "terrible casting").
- The actors "can't act," possibly because they have been poached from the theater department, where they are trained for stage performances, which is very different from screen acting: instead of trying to avoid "stepping on" other actors' lines, TV actors deliver lines more rapidly, especially in comedy. The slower pacing of stage acting totally kills the comic timing that TV audiences are accustomed to, making every "dead" nanosecond between jokes feel like an eternity – leaving your student writers in despair because everything feels so drawn-out and flat.
- The sets are wrong, probably due to limited resources; it's not likely that a school or university can afford to build

a chic, ultramodern condo or a retro 1950s kitchen for a student production.

- There's no slo-mo/fast-mo or other specified post-production effects because the editors haven't advanced to that level or don't have the right equipment/software.
- The song in the musical number is a generic public-domain substitute for the copyrighted radio hit specified in the script. (This one really puts the "rage" in "umbrage"!)

Such traumas are unavoidable, but instructors can mitigate the damage with pre-emptive therapy: warn the writers that all of the great stuff in their imaginations cannot possibly translate perfectly into casting or production – and let them know *that's okay*, they shouldn't agonize about it. If your students get to be on set during filming, keep a box of tissues handy (no joke – crying happens). Devote part of the next class session to debriefing, and don't overlook the possibility that some of the perceived disasters happened because the writers didn't make what they wanted completely clear; again, if it ain't on the page, it ain't on the stage. But most of all, kindly help the students toughen up, because this is the fate of every screenwriter. Fortunately, it does get easier.

Index

Note: Page numbers in italics indicate figures.

157